Contemporary Art Decoded

Contemporary Art Decoded
Jessica Cerasi

An Hachette UK Company
www.hachette.co.uk

First published in the United Kingdom in 2021
by ILEX, an imprint of Octopus Publishing Group Ltd

Octopus Publishing Group, Carmelite House,
50 Victoria Embankment, London, EC4Y 0DZ
www.octopusbooks.co.uk
www.octopusbooks.co.uk

Distributed in the US by Hachette Book Group
1290 Avenue of the Americas, 4th & 5th Floors
New York, NY 10104

Distributed in Canada by Canadian Manda Group
664 Annette St, Toronto, Ontario, Canda M6S2C8

Publisher: Alison Starling
Commissioning Editor: Ellie Corbett
Managing Editor: Rachel Silverlight
Art Director: Ben Gardiner
Design: She Was Only
Picture Research: Giulia Hetherington and Jennifer Veall
Production Manager: Nic Jones

Ilex are proud to partner with Tate in our publishing
programme; supporting the gallery in its mission to
promote public understanding and enjoyment of
British, modern and contemporary art.

ISBN 978-1-78157-745-5

A CIP catalogue record for this book is available
from the British Library

Printed and bound in China

10 9 8 7 6 5 4 3 2 1

Contents

Introduction

If you're reading this, the chances are you're looking for answers. And who can blame you? Contemporary art can be challenging! However, while I hope you find the pages that follow informative, my ambition is to leave you with more questions. I have been tasked here with 'decoding' contemporary art, but the truth is that there isn't really a code to crack. A code suggests that only one essential meaning is there to be discovered, if only it can be translated properly. But art, by its very nature, depends on the fact that meanings are multiple and fluid. Poetry resides in interpretations being open. What I see and what I feel is different from what you might see or feel, and there is beauty to be found in our different perspectives. To fully crack the code would be like revealing what's behind a magic trick. If there were a code, it wouldn't be art at all.

To that end, the 'explanations' of artworks put forward here are not intended to fix meanings but rather to open them up. I hope to give you a starting point, pique your interest and boost your confidence when encountering contemporary art in the future. These works provoke many questions, and I hope you'll find them new and interesting. As you will see, the artworks included here are grouped around ten provocations, but many of them could just as easily sit within more than one chapter. All these paintings, photographs, sculptures, textiles, installations and performances engage with the themes of contemporary life, as broad-ranging as climate change, expanding the gender binary, gentrification, migration and racial equality, to name but a few. Moreover, many of the concepts covered here are timeless themes of existence: how we see, how we communicate and how we can live together.

In selecting the works to include, I wanted to put together a grouping that felt fresh and included artists of a younger generation. In terms of the timeframe represented here, it is worth noting that the date when 'contemporary art' begins is much contested. Some scholars refer to art made after the Second World War, while others draw the line around the fall of the Berlin Wall and the emergence of the 'global village' in 1989. Nonetheless, most historians agree that a significant breakpoint occurred in the 1960s when numerous experimental practices came to the fore. As such, I have focused primarily on art made in the last thirty years, with some notable exceptions that anchor the more recent works within the context of earlier generations.

Art history is much more expansive than a list of the same old names wheeled out time and again. I have chosen to include more women and tell a story that acknowledges contributions that have often been overlooked. That said, I also have privileged works that I have been lucky enough to see and experience in person, and therefore the selection reveals my position in London. It aspires to an international outlook, but inevitably this is a personal and partial view, and by no means exhaustive. A thousand parallel versions exist with different artists and different themes: contained here is simply a snapshot of a landscape in flux.

Finally, I wanted to acknowledge and extend my boundless gratitude to the artists in this book. In sharing their work here, I have also sought to share some of their thinking and have included artists' quotes where possible. After all, they are the best authorities to speak on their work.

What is
contemporary art?
What is
contemporary art?
What is
contemporary art?
What is
contemporary art?
What is
contemporary art?
What is
contemporary art?
What is
contemporary art?

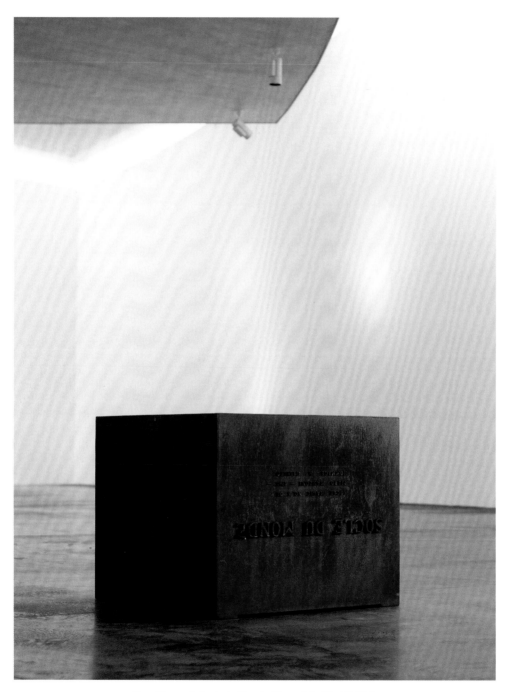

Piero Manzoni, *Socle du Monde (Base of the World)*, 1961

In 1961, Italian artist Piero Manzoni did something very simple but hugely impactful. Instead of following the convention of making a sculpture to display on a plinth, he took the plinth and turned it upside down. The plinth itself became a platform for the world, and the whole world became his sculpture. With just one shift of perspective, the entire planet can be understood as art. He showcased what was right under our feet, and what we so often take for granted.

That is the magic of contemporary art. Sometimes an unexpected mental leap can turn an upside-down plinth into a staggeringly beautiful metaphor and way of looking at the world. Contemporary art is often not just about the object in front of you, but the ideas it can prompt if you give it a little time.

In school, many of us are taught to think of art as craft. If we're lucky, we are taught techniques for drawing a face so that it closely resembles that of the person opposite us: the way their eyes catch the light, the wrinkle at the corner of their mouth. We learn that achieving a close likeness is hard work and we respect the artist's ability to conjure life from a blank page. Years later, perhaps we are inspired to visit a cutting-edge art gallery and see what contemporary art – the art of today's artists – has to offer. Is it any wonder when confusion sets in as we find that very little tallies with what we have been taught?

Contemporary art is slippery and full of contradictions. We often think of contemporary art as conceptual art. The idea is what matters; it is not about how something is made. But then it's not *not* about how it's made. Manzoni's plinth is not any old plinth. It is the heavy-set plinth of historic public sculptures; think military generals and equestrian statues. It's rusted and aged, suggesting a monument that has passed into disrepair, or perhaps an old pedestal that is being repurposed and given a new life. The way it looks is not incidental, but the work *is* also largely conceptual: it's about the idea of the world as a sculpture. But, then again, it's also about more than that. It's about the concept of sculpture itself, and the expectations we use to constrict what sculpture can be. Sculpture is historically the act of using skill to make something unique from raw materials. Where is the sculpture here? Can Manzoni take ownership of the planet by laying claim to it in this way? What is the role of the artist if we allow him this conceit?

These are questions that it is up to each of us to answer for ourselves. Manzoni presents us with a proposition: it is our prerogative to decide whether we choose to run with it – or not. As early as 1947, the American painter Mark Rothko wrote: 'A picture lives by companionship, expanding and quickening in the eyes of the sensitive observer. It dies by the same token.'[1] Defining contemporary art is a virtually impossible task

since, in its widest sense, it can be understood as the entirety of art produced in the last sixty-odd years. It is a broad term that can encompass a huge range of work and therefore conveys very little beyond a timeframe. This sweeping definition is the most accurate but the least satisfying. If we attempt to venture further, we might say that a defining feature of much contemporary art is this notion of placing the onus on the viewer to bring the work to life.

Fast forward to a more recent work: the Polish-German artist Alicja Kwade's large-scale installation *WeltenLinie* (2017), an arrangement of steel grids and mirrors that you can walk around and pass through. As you navigate the space, objects positioned within the structure seem to appear and disappear, or morph from one material into another. A rock in one view is a rock, and in the next instant it lines up perfectly so that the same rock appears cast in bronze. You assume one panel is a mirror, but you do not find your reflection. It is an unsettling series of illusions held together by a complex system of double-sided mirrors and delicately positioned, paired objects.

Like *Socle du Monde* (*Base of the World*), this is a work about perception. As we move around it, we don't see what we expect to see, which makes us more aware of our movements within the space and the act of looking at sculpture. These are static objects that through the process of our walking appear mutable. In this sense, our footsteps around the work allow it to become more than a collection of things. The title *WeltenLinie* is German for 'world line', which is a term describing an object's path through spacetime (a concept from physics in which the three dimensions of space are fused with the fourth dimension of time). As we navigate space over time, our perspective shifts, and this is where the work resides. It requires the viewer's engagement for it to come into effect.

Both Manzoni and Kwade are challenging our preconceptions of what sculpture can be, whether as a concept rather than a new creation, or a sequential experience instead of a fixed object. This breaking with convention is another distinctive aspect of much contemporary art. It seeks to articulate a new language for our times, and does so by attempting to free itself from the constraints placed on the art that has come before. It provokes, and it questions, and it rarely plays it safe by giving us exactly what we expect. That's what can make it so challenging, but also what makes it so exhilarating.

This chapter looks at a selection of works that offer a flavour of how varied contemporary art can be. Each one intrigues, surprises and encourages consideration of broader issues in its own unique and ingenious ways.

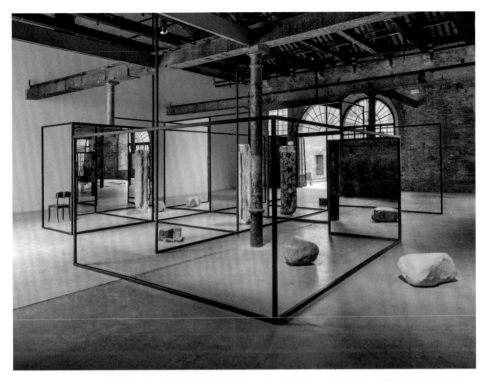

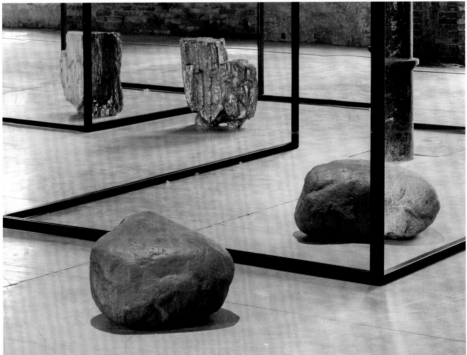

Alicja Kwade, *WeltenLinie*, 2017

Martine Gutierrez, still from *Clubbing*, 2012

American artist Martine Gutierrez's three-minute video *Clubbing* is captivating. The film begins with a woman coyly turning towards the camera. She wears a heavily embellished sequined dress and looks downwards, while cartoonish pantomime eyes, painted on just beneath her own, meet our gaze. Next, a man in a swirly sequined suit turns to look at us with the same painted eye makeup, as he adjusts his sparkly bow tie. As though painted on a mirror in glittery nail varnish, the title frame announces 'Clubbing', and we are off!

The dance moves skate between staged choreography and improvisation, recalling the shimmying dancers on popular music shows from the sixties and seventies like *American Bandstand* or *Soul Train*. At one point, the woman gives the camera a look as if to say she is fully aware that her mini-skirt has ridden up to reveal her underpants, but who cares! A second couple enters the scene. And then a third. One could be forgiven for thinking that six different people are dancing together onstage. However, all of these figures are played by the artist.

Martine Gutierrez shot several videos of herself in elaborate costumes, dancing on her own and edited them together in post-production. *Clubbing* is more than a joyous film about people dancing, it is a playful comment on gender, and the many selves within each of us. Herself a trans woman, Gutierrez notes: 'The idea of "gender roles" really sums it up – these are parts we play… It's important to emphasize that outside of these artificial boundaries we're both inherently equal and profoundly, infinitely diverse.'[2] Indeed, the pantomime eye makeup of the characters in *Clubbing* alludes to how theatrical and performative our self-presentation can be. Gutierrez seems to beckon us to follow her characters' lead. There is much joy and freedom to be found in living out our sequined fantasies and performing gender as we please.

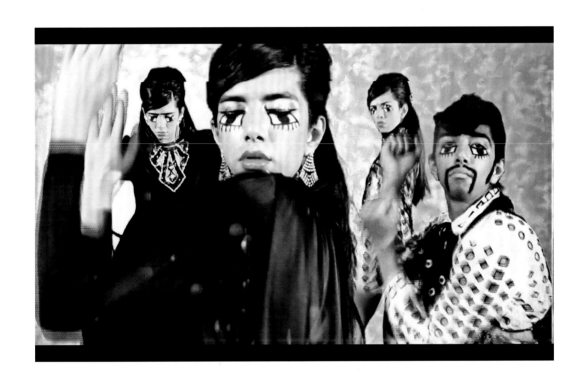

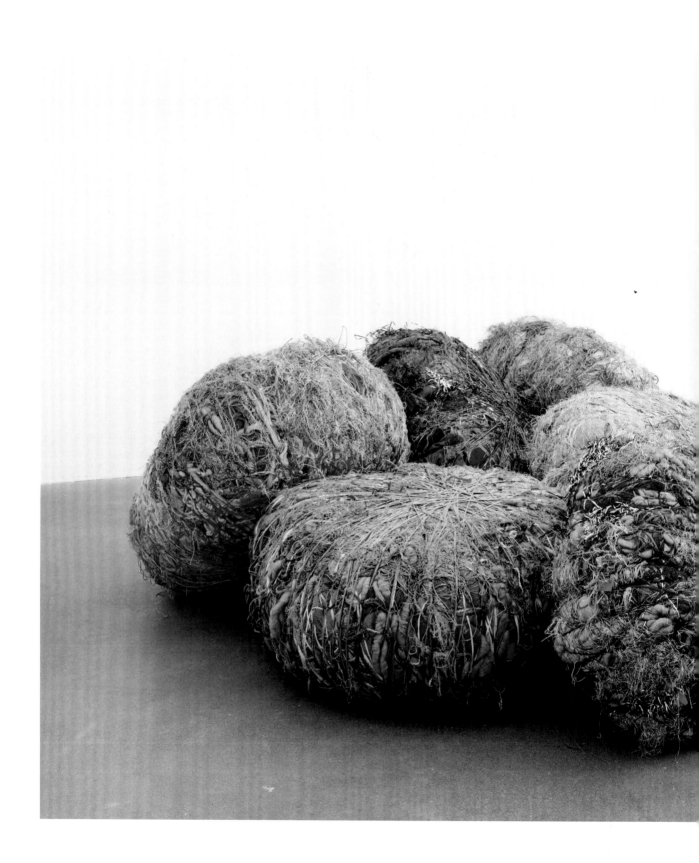

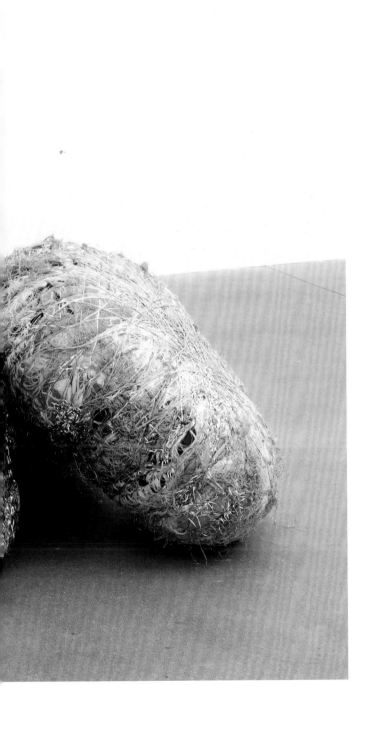

Sheila Hicks, *Grand Boules*, 2009

Sheila Hicks' works make even the most well-behaved gallery visitor want to touch them. Having worked with textiles for over sixty years now, the American artist has evolved a practice that uses colour and texture to engage our visual and tactile senses in an almost intoxicating way. I'll admit it: I'm desperate to hug one of her *Grand Boules*.

Each is a mix of wool, silk, cotton, linen, hemp and synthetic yarns, tightly bound into a bale almost a metre in width. Upon closer inspection, each of the various thicknesses of thread has been handled differently: the thicker threads loop in distinctive squiggles while thinner ones are sometimes appended as tangled masses. A single-coloured twine binds the outside of each one, overlapping at the centre in dense star-shapes.

Each creation is like an abstract painting, a unique composition of form and colour, that communicates a particular experience to the viewer. Indeed, they can also be understood as drawings in that they are built up entirely from line. Or they can be seen as sculptures – but soft, raggedy shapes, clustered on the ground, rather than classical forms of marble or bronze on a pedestal. Instead of elevation and grandeur, they suggest the familiar and the hand-made.

This familiarity is an important aspect for Hicks who understands textiles as a universal language, common to every culture and growing out of the basic human needs of warmth and shelter. Yet, understanding these works within an artistic context of painting, drawing and sculpture is significant too. Likely because they are often associated with 'women's work', Hicks explains, textiles have largely 'been relegated to a secondary role in our society, to a material that was either functional or decorative. I wanted to give it another status and show what an artist can do with these incredible materials.'[3]

**Yayoi Kusama, *Infinity Mirrored Room –
Filled with the Brilliance of Life*, 2011/2017**

Just looking at an image of one of Yayoi Kusama's
Infinity Mirrored Room installations is breath-
taking. To step into one and experience its
vistas stretching out all around you is an almost
transcendental experience. All at once, you are
floating among the stars, unable to grasp how the
four walls that confined you only a moment ago
are miraculously able to expand so magnificently
into this.

In *Infinity Mirrored Room – Filled with the
Brilliance of Life*, hundreds of tiny LED lights
hang from the ceiling, programmed to twinkle
in different colours. The walls and the ceiling
are mirrored, along with the walkway on the
ground that guides you through. Surrounding the
walkway is a shallow pool of water which again
reflects the lights in looser ripples. The combined
effect is one of a dazzling kaleidoscope without
end; as the title describes, in this moment, the
'brilliance of life' feels irrefutable. But it is only a
moment! The fragility and immense popularity of
Kusama's installations mean that crowds must be
managed, and visitors are only ever allowed to
enter for a few short minutes. The fleeting nature
of the experience only adds to its dreamlike
quality. There is no time to unpick the illusion,
only to absorb the sense of awe it inspires.

Across a career spanning more than
seventy years, Kusama has explored concepts
of endlessness through works that incorporate
pattern and repetition. Since childhood, she has
suffered with hallucinatory episodes where vast
expanses of dots envelope her field of vision.
These works are all the more astonishing when
we understand they have their roots in such
deeply personal and unsettling experiences.

At the same time, it is important to note their
place in art history, as shifting the conventional
relationship between the viewer and artwork, by
having the artwork surround the viewer. When
we walk around a sculpture, we have the control.
When the work surrounds us, we become aware
of ourselves as bodies in space in a different way.
This feeling of floating among the stars reminds
us that we are just one body among eight billion
on a planet that is, in actual fact, floating among
the stars. It's all a little dizzying; for now, perhaps
the best way to anchor ourselves in all of this is to
succumb, let go and bask in its wonder.

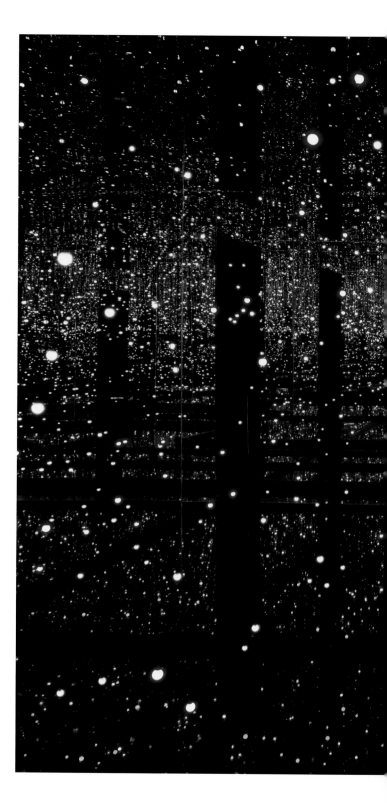

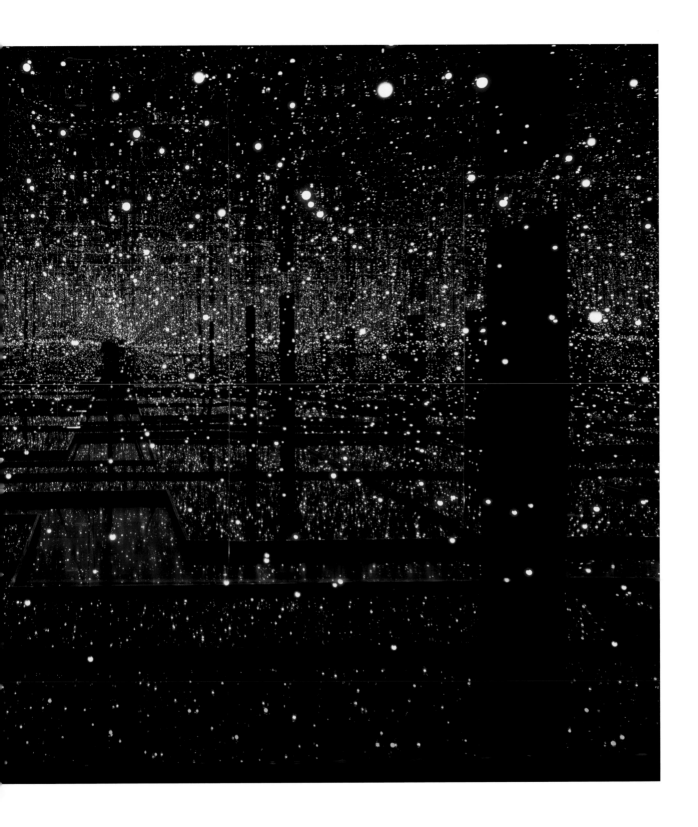

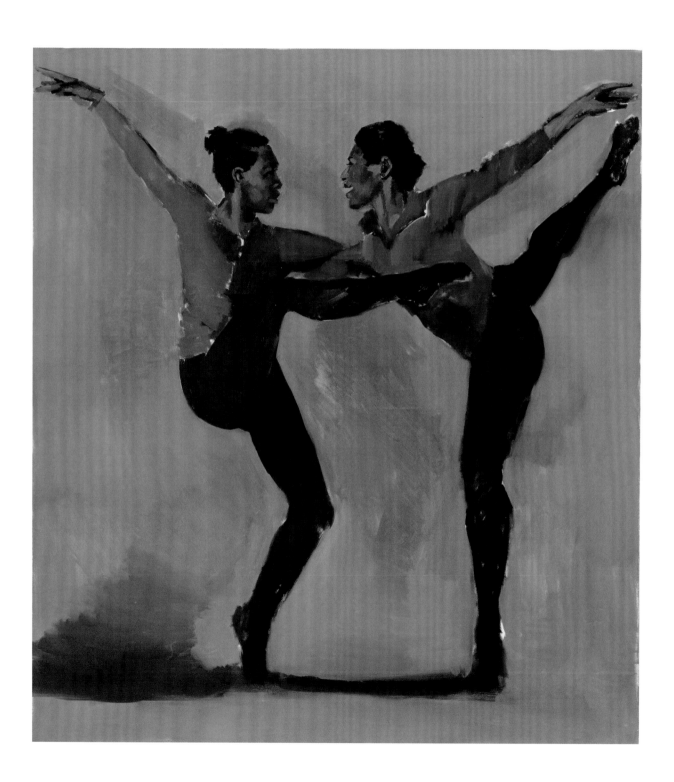

What is contemporary art?

Lynette Yiadom-Boakye, *To Douse the Devil for a Ducat*, 2015

To Douse the Devil for a Ducat depicts what seems to be a fleeting moment of two dancers holding each other's gaze, while forming striking poses, each with one leg raised in the air. In locking eyes with one another, both women seem unaware of the artist. They are not posing for their portraits. Rather, they appear to be delighting in the exhilaration of finally managing to get that move right or the exuberance of moving seamlessly in tandem with another person. What music animates this instance of pure joy is known only to them. As viewers, we see a scene brimming with possibility, an invitation to imagine a narrative.

All the figures in British artist Lynette Yiadom-Boakye's work are imagined characters. The artist draws inspiration from scrapbooks, photographs, memories and some life drawing, but her paintings are not portraits of real people. At art school, she realised she was less interested in rendering a sitter's likeness than in the paint itself. This is reflected in her working process: the artist does not use preparatory sketches, but rather forms her compositions directly on the canvas, allowing the images to emerge through the act of painting. She explains, 'This lets me really think through the painting, to allow these to be paintings in the most physical sense, and build a language that didn't feel as if I was trying to take something out of life and translate it into painting, but that actually allowed the paint to do the talking.'[4]

All the figures in Yiadom-Boakye's work are also Black. She describes this as only natural, given she is Black herself, but also inherently political. Not in the sense of disrupting an art historical canon that has largely cast Black figures within painting in subordinate or demeaning roles (although her works do accomplish that), but more in the simple fact that her figures are shown with their own autonomy in moments of everyday contentment. As she describes, they are 'of the world but only partially concerned with it. Concerned with the part that gives them life, less bothered by the rest.'[5]

Rugilė Barzdžiukaitė, Vaiva Grainytė, Lina Lapelytė, *Sun & Sea (Marina)*, 2019

Sun & Sea (Marina) was the talk of the 2019 Venice Biennale and it won Lithuania the Golden Lion – the top award – for Best National Participation. To view the work, visitors must enter an old warehouse and climb the stairs to a viewing gallery. As they peer over the balcony, they miraculously find that they are gazing down over a beach, complete with sand, sun loungers, parasols, and buckets and spades, with people of all ages taking in the sun and, what's more, they're all singing. For this is a modern-day opera about climate change.

As the characters take turns breaking into song, it transpires that the things that run through each of their minds are also familiar to many of us: from globalisation and extinction, to sunscreen, exhaustion and the carbon footprint of bananas. The lyrics, in tunes such as the 'Sunscreen Bossa Nova', 'Chanson of Too Much Sun', and 'Wealthy Mommy's Song', are sharply incisive as well as blisteringly funny.

Spectators are lulled into a sort of sun-soaked daze, until they realise that this is how the end times unfold. As Grainytė puts it, 'It's about nothingness – nothing is happening,' and yet the world is changing in the background.[6] The experience of *Sun & Sea (Marina)* is like gazing into the kind of diorama one might see at a museum of natural history showing wax figures of cavepeople going about their business in an era long since passed. Yet, these are real people and the time is now – are we living in days soon to pass out of existence? As sea levels and temperatures rise with global warming, our languid beach holidays wasted frittering over trifling concerns could become the stuff of museums before we know it.

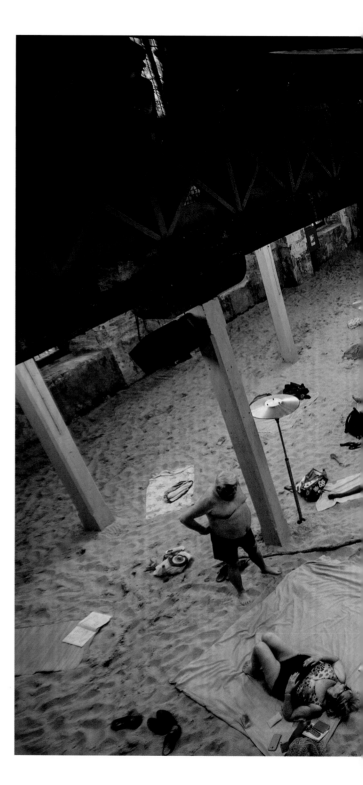

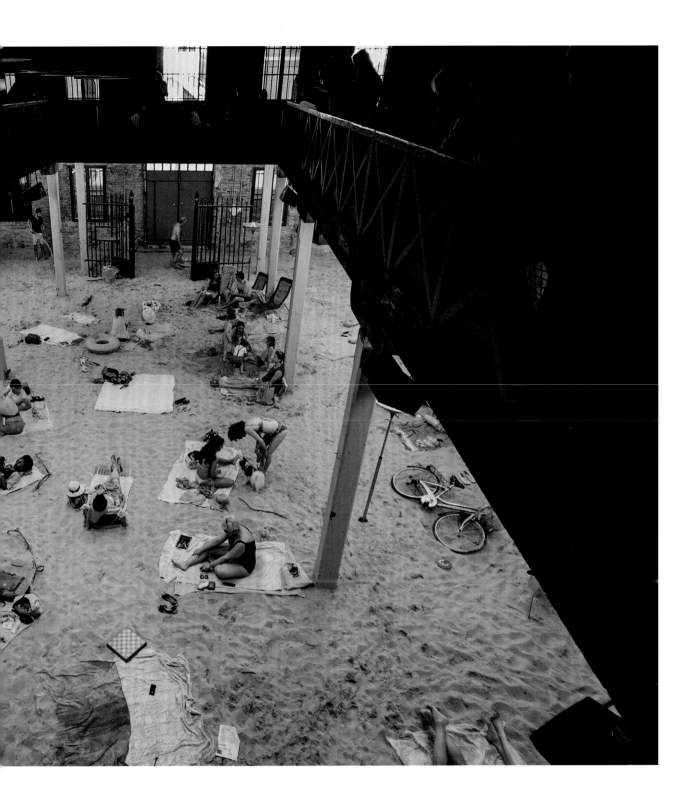

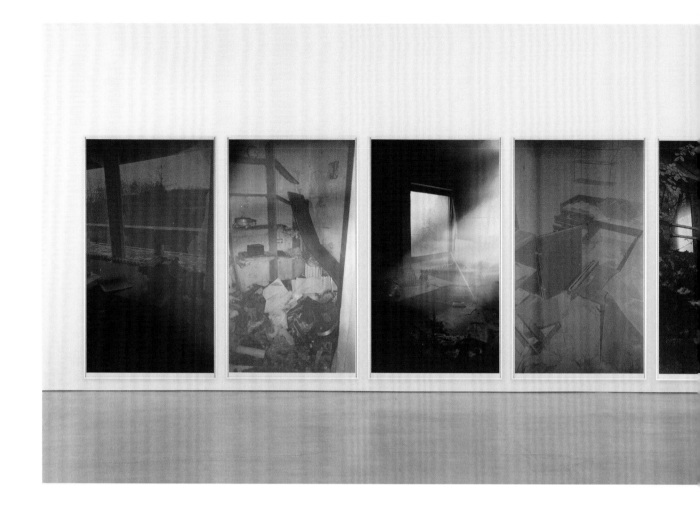

Walead Beshty, *Travel Pictures [Tschaikowskistrasse 17 in
multiple exposures* (LAXFRATHF/TXLCPHSEALAX) March 27–
April 3, 2006] *Contax G-2, L-3 Communications eXaminer 3DX
6000, and InVision Technologies CTX 5000,* 2006/2008

Between 2001 and 2006, Walead Beshty made several visits
to an abandoned building in Berlin that formerly housed the
Iraqi Embassy of East Germany, prior to German reunification
in 1990. He had learned about the location shortly before the
outbreak of the first Gulf War, from a newspaper report on
a fire in the building caused by squatters. Laws protecting
national sovereignty meant that German officials could not
enter the grounds legally, even though neither the German
Democratic Republic nor the Republic of Iraq remained in
existence. In Beshty's words, it was 'a relic of two bygone
regimes, unclaimable by any nation; a physical location
marooned between symbolic shifts in global politics.'[7]

On a return journey from Berlin to his studio in Los
Angeles, where the London-born artist is based, he accidentally
left some photographic film in his cabin baggage and it
became damaged by airport security X-ray machines. The
result was the unusual colouration, bands and flares you see

etched onto the prints. Rather than viewing the photographs
as destroyed, Beshty came to see these marks as a fruitful
accident. As with the neglect of the embassy, this damage was
also a consequence of political history. X-ray machines were
first installed at airport checkpoints during the 1970s to prevent
hijackings, and airport security was tightened following the 9/11
attacks on the World Trade Center in New York City in 2001.

The airport X-ray machines thus became the artist's unwitting
collaborators, and he affords them due credit by listing the names
of the devices and the codes of each of the airports through
which the film passed in the series' long title. As he travelled to
and from Berlin, Beshty also came to see broader parallels in the
indeterminate space of the former embassy and the transitional
zones we pass through as part of modern air travel: airport
security and customs. In this sense, these photographs reflect not
only the fragile nature of photography, but also the delicate social
contracts intended to protect us.

Young-Hae Chang Heavy Industries,
THE ART OF SLEEP, 2006 [stills]

Watching Young-Hae Chang Heavy Industries'
THE ART OF SLEEP is a strangely unnerving
experience. You view it online, and once you
click the link it starts playing immediately.
Frustratingly, you can't make it full screen, can't
pause, can't rewind. Once it's running, it's running
– like a cinema in your browser. The protagonist
sets the pace, not the audience. It is we who have
to keep up. This can be quite a challenge because
the entire film is composed of texts that flash up
on screen. To follow the narrative, you must keep
your concentration and read fast.

 We are invited on a winding tale told by
someone kept up at night by their neighbour's
whining dog. Unable to sleep, our narrator has
just made an 'earth-shaking discovery' about the
nature of art. We are told that art can be anything,
but it has dawned on our narrator that, in fact,
'art is everything'. It's the kind of epiphany that
skates the line between being incredibly profound
and incredibly banal, and it encapsulates all the
difficulties and absurdities at play when trying to
untangle the concept of art.

 Made for the computer screen, this is likely
a work of art that you watch alone, in the comfort
of your own home, and this establishes a
relationship with the narrator that is much more
intimate than it would be, had this been a work
for an art gallery. There is a sense of entering
the mind of another and sharing in late night
musings that are very personal to them.

 Young-Hae Chang Heavy Industries is a
collaboration between Korean artist Young-Hae
Chang and American artist Marc Voge, who both
live and work in Seoul. For more than twenty
years, they have used Flash animation to make
text-based works of art. Commissioned for Tate
Online to coincide with Frieze Art Fair in 2006,
THE ART OF SLEEP presents an entertaining
and thought-provoking meditation on the
international art market, being an artist, and
the nature of art itself. You are left as though
awakening from a dream, unsure quite what
you just experienced: maybe a rare insight into
something fundamental, perhaps nothing more
than a flight of fancy.

ASK SØME GUY IN THE STREET IF ART IS WØRTH A DAMN, HE'LL SMACK YØU UPSIDE THE HEAD JUST FØR ASKING.

GRAB A CRITICAL THEØRIST AND SAY: *ART IS LIKE THE WHINING ØF A DØG IN THE NIGHT.*

ART CRITICISM? HA! CRITICISM SCHMITICISM.

ART IS FUTILITY ITSELF. THAT'S ITS BEAUTY.

Where did it come from?
Where did it come from?
Where did it come from?
Where did it come from?
Where did it come from?
Where did it come from?
Where did it come from?
Where did it come from?

Contemporary art is a global phenomenon, and as such it possesses as many different histories as there are corners of the world. As with tracing ancestry, we can follow its lineage back through generations and find a variety of beginnings. If we are to understand where we are with contemporary art today, it's helpful to have a sense of how we got here. So what better place to start than with the work that was named as the single most influential artwork of the twentieth century? You guessed it: The *Fountain*.

In 1917, a standard urinal signed 'R. Mutt 1917' was anonymously submitted as an artwork to the first exhibition of the Society of Independent Artists in New York. The newly established Society had been heralded as jury-free, bound to accept all members' submissions. Nonetheless, after a discussion and a vote, the submission was rejected by the board, with the following statement: '*[Fountain]* may be a very useful object in its place, but its place is not in an art exhibition and it is, by no definition, a work of art.'[1] It is hard to read that comment today without a wry smirk. But frankly, many still feel the same way.

It is quite astonishing to think that this work is over a hundred years old, when much of the outrage it provoked still feels so incendiary. What place could a mass-produced urinal possibly have in an art gallery? This question is exactly the point. It is this incongruence between the object and its context that makes the work so groundbreaking. Before *Fountain*, audiences rarely had to think through what art actually was – it was self-evident: either a painting or a sculpture. But if you accept an object as lowly as the *Fountain* as art, then surely art can be anything? And if art can be anything, then what makes it art? The fact that it is displayed in an exhibition? The fact that it is made by an artist? And who gets to decide?

These are all questions we continue to ask about much contemporary art today. Because 'art' itself is a concept and cannot be reduced to a set of criteria, despite the expectations of skill, authorship and uniqueness we might have for it. *Fountain* complicates each one of these notions. Rather than traditional artistic skill, in this instance it is a boldly presented idea that forces a reassessment of our previously held assumptions. Authorship can no longer be about the artist's distinct style when the work is industrially produced and they had no hand in its making. If uniqueness persists, it can only be in the value now afforded this particular object over the same mass-produced one installed in the lavatory.

With *Fountain*, the question of authorship is even harder to answer. In 1935, French-American artist Marcel Duchamp claimed to have made it, and the work has long been understood within the context of his practice. However, in the past two decades, new

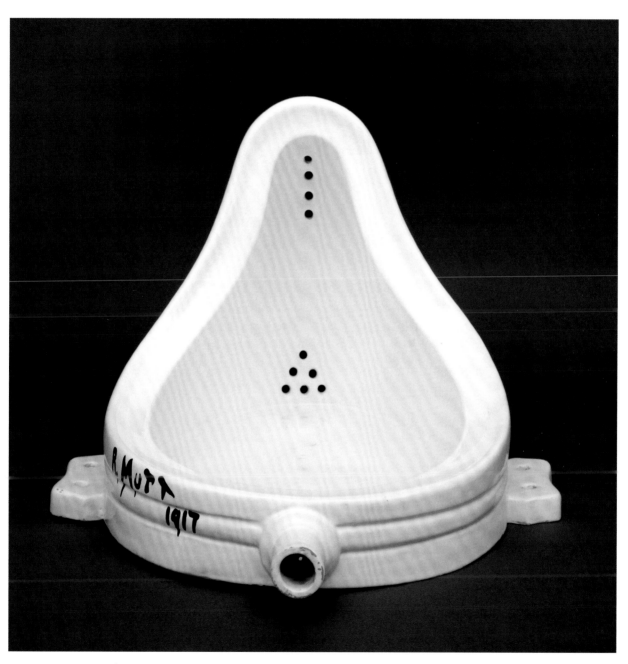

Marcel Duchamp, *Fountain*, 1917
[Replica, 1964]

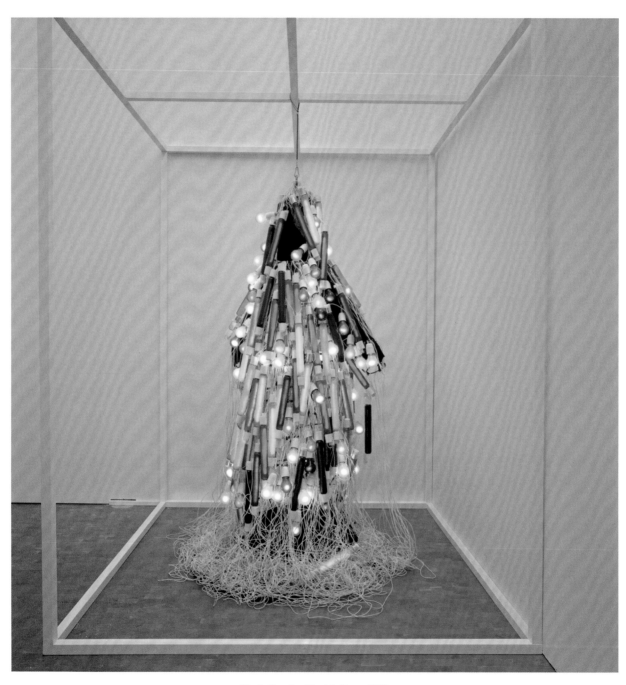

Atsuko Tanaka, *Electric Dress*, 1956
[reconstruction, Galerie Jeu de Paume, 1999]

scholarship has emerged to suggest the *Fountain* was in fact made by German-American poet and artist Baroness Elsa von Freytag-Loringhoven. It is likely we will never know the truth, but whoever made it was ahead of their time.

After the First World War, art shifted away from the vanguards of the early twentieth century, in what has been described as a 'return to order'. It was not until the early 1950s that interest in the R. Mutt affair of 1917 began to grow and a generation of younger artists were to be inspired by this work.

One important legacy of *Fountain*, and Duchamp's 'readymades' more broadly, was the introduction of items from everyday life into the realm of high art. The American painter Robert Rauschenberg – who began his combinations of paintings and found objects known as 'combines' in 1954 – once commented that there were few things in his daily life that had to do with oil paint. The decision to move away from traditional art materials was a conscious effort to find a language that was more reflective of the actual stuff of everyday life.

This burgeoning of experimental practices was not limited to New York. In Tokyo, the avant-garde Gutai group had formed in 1954 with the rallying cry to 'create what has never been done before!'[2] They sought a break with the past and a new beginning in order to put the horrors Japan experienced in the Second World War behind them. Spanning painting, installation, performance and 'happenings' that took place outside of art spaces, theirs was a radical approach.

One particularly exceptional work of that period was Atsuko Tanaka's *Electric Dress* which she presented at the Second Gutai Art Exhibition of 1956. Inspired by the neon lights of the billboards at Osaka station, she decided to make a neon dress that could represent Japan's rapidly industrialising economy and changing fortunes. She strung together hundreds of light bulbs in various shapes and sizes, painted them in bright colours, and assembled them into a kind of outfit. Wearing it was no small feat: the light bulbs were heavy and would get hot, and each bulb was connected to a mass of electrical wiring, bringing with

it the risk of electrocution. Tanaka describes trying the dress on for the first time: 'When I was finished, I was uncomfortable with the electrical connections. Since somebody had to wear it, I covered myself with vinyl and put the electric dress on.' When the electrician first switched it on, she noted 'the fleeting thought: Is this how a death-row inmate would feel?'[3]

It made for an eerie performance as she crossed the exhibition hall slowly because of the dress's weight and unwieldiness, the gaudy lights twinkling. The dress was both a glitzy, tacky, Christmas-tree-like visual delight and a dangerous piece of technology that threatened to electrocute its wearer. It not only alluded to the traditional Japanese kimono, but also the bright lights of a growing city and the dangers technological advancement could pose, particularly poignant in the wake of the atomic bombs dropped on Hiroshima and Nagasaki in 1945. As a wearable art piece, *Electric Dress* was also intimately connected to the artist's body and the perilous performance that accompanied it likewise presaged many of the radical feminist performance art practices that were to follow in the 1960s and 1970s.

Women's contributions to art and art history have long been side-lined and overlooked. Over the span of the twentieth century this gradually began to shift and artists like Tanaka afforded due credit, but there have been many important women artists whose names we still do not know. The same can be said for non-Western artists, and artists of colour. Though the truth about *Fountain*'s authorship might be ambiguous, the story feels all too familiar. Duchamp's name and works are famous and his significance, indelible; Von Freytag-Loringhoven, although well-known among her peers and New York art circles in the 1910s and 1920s, has only recently started garnering the attention of a contemporary audience. In not knowing her work and that of countless others like her, we are all the poorer. Today, there is much interest and investment in discovering and celebrating what has previously been ignored and undervalued. But there is still a great deal to be done.

Where did it come from?

Lygia Clark, *Creature-Maquette (320)*, 1964

'Please do not touch' is a refrain we are trained to respect when visiting art galleries. Not so with Brazilian artist Lygia Clark's series of '*Bicho*' sculptures. These objects were designed to be handled, not passively observed.

From 1959 into the 1960s, Clark made about seventy hinged metal sculptures. Each one was made up of geometrical metal shapes, connected together in different configurations. They have no fixed position in which they should be displayed: no front or back, top or bottom, inside or outside. Each one, in fact, comprises many different sculptural possibilities.

Yet, while these works may be pliable, these possibilities are not infinite. As you handle them, you find that the range of possible movements is guided by the directions of the hinges and the connections of the various planes. Clark referred to these works as '*Bichos*', Portuguese for 'beasts' or 'creatures', because each one has a life of its own. She explained: 'The arrangement of metal plates determines the positions of the *Bicho*, which at first glance seems unlimited. When asked how many moves a *Bicho* can make, I reply, "I don't know, you don't know, but it knows."'[4]

These days, these sculptures are historic artefacts and they present curators with a challenge of how to exhibit them. More often than not they are displayed as though trapped in glass cabinets, in a fixed configuration. This is ideally counteracted by rearranging their forms throughout the run of the exhibition, or building replicas that visitors are permitted to handle.

In the past two decades, there has been a growing shift towards interactivity in museums. We see this in the rise of large-scale experiential installations, comments boards and an emphasis on social media engagement. Clark's *Bichos* were an early step in re-articulating the relationship between visitor and artwork, away from a passive consumption and towards an active participation.

Sam Gilliam, *Double Merge*, 1968

There is a vastness and majesty in how Sam Gilliam's painted canvases *Double Merge* occupy a gallery space. Two large-scale unstretched canvases hang from the ceiling, draping and falling like royal robes or theatre curtains. Each is titled *Carousel II* for the sweeping movement articulated within its form, and together they 'merge' into one work.

By removing the frame and dispensing with the classic 'picture window' wall-mounted painting, Gilliam collapses the distinction between painting and sculpture. In some ways, he understood these works as liberating the 'properties inherent to canvas itself … allowing the canvas to be exactly what it really is – a flexible, drapeable piece of cloth.'[5] Yet, he has always emphasised these works ultimately as paintings, not sculptures. They are formed by placing canvas on the floor and pouring, staining and folding paint onto it in a rich variety of fluorescent colours: hot pink, deep purple, lurid green, sherbet orange, accentuated by pops of silver. The colour relationships evoke the abstract expressionist paintings of the preceding generation, but here the dynamic effect conjured on the painted surface is mirrored in the works' form. Gilliam explains that these 'gravity-formed' paintings are 'exhibited in a way consistent with the manner in which they were made.'[6]

Inspired by clothes hanging on a line, there is also an everyday quality to these drape paintings, as they leave the gilt frame behind. Made in 1968, at the height of the civil rights movement, by a Black artist, these works sought to re-articulate art's place in a society experiencing intense changes. For Gilliam, 'The surface is no longer the final plane of the work. It is instead the beginning of an advance into the theater of life.'[7]

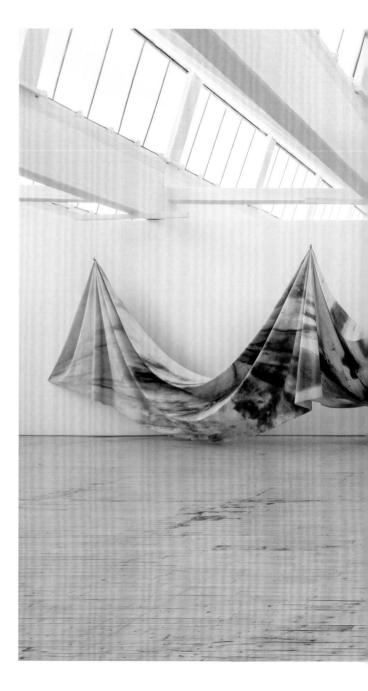

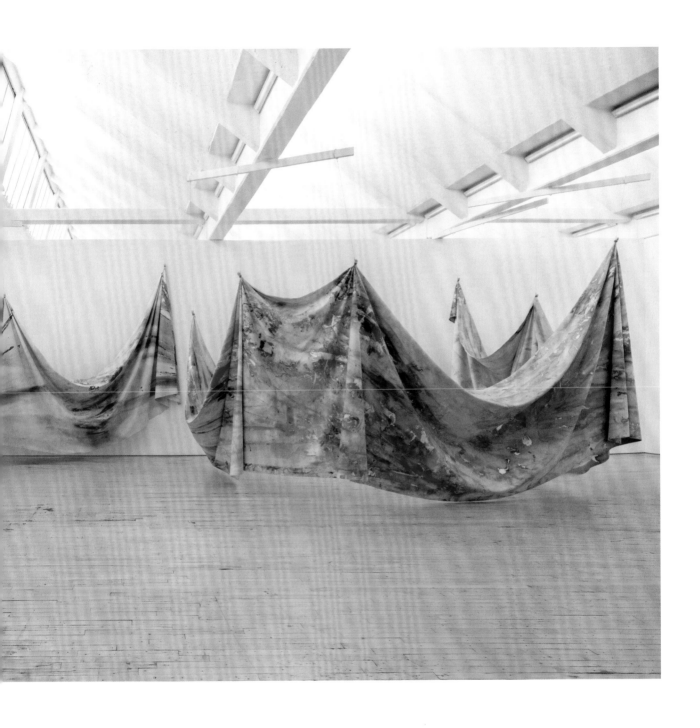

Carolee Schneemann, *Interior Scroll*, 1975

If we think back through the story we are told of art history, the women artists that come to mind appear to be rare exceptions to a narrative populated by male 'geniuses'. In the 1960s and 1970s, that balance began to shift as a generation of women artists started making their mark in radical ways.

In 1975, American artist Carolee Schneemann performed her work *Interior Scroll* to a room full of mostly female artists. In front of the audience, she undressed, painted herself in mud and enacted a series of life model 'action poses'[8] before standing on a table, slowly unravelling a reel of paper from her vagina and reading from it a text that she had written. This was a woman who was not messing around. Describing her motivations behind the performance, she later said: 'I didn't want to pull a scroll out of my vagina and read it in public, but the culture's terror of my making overt what it wished to suppress fueled the image.'[9]

The text she read recounts a conversation between herself and a 'structuralist filmmaker' that epitomised some of the struggles she faced as a woman artist. The filmmaker espouses systems, logic and rationality, while Schneemann's work draws on unacceptably 'female' notions of intuition, emotion, personal experience, and embodied knowledge. For Schneemann, the creative process was one innately tied to the body, physicality and sexuality.

Interior Scroll was radical not only from a feminist perspective, but also because Schneemann always considered herself a painter. She understood painting as a form of activation, and her role as that of 'a painter who has left the canvas to activate actual space and live time.'[10] Unfortunately, today all that remains of her performance are a handful of photographs and transcribed texts. But the image of a naked woman confidently reading a message from her vagina has no less power.

CAROLEE SCHNEEMANN

Reading from
THE INTERIOR SCROLL:

I MET A HAPPY MAN
A STRUCTURALIST FILMMAKER
--BUT DON'T CALL ME THAT
IT'S SOMETHING ELSE I DO--
HE SAID WE ARE FOND OF YOU
YOU ARE CHARMING
BUT DON'T ASK US TO LOOK
AT YOUR FILMS
THERE ARE CERTAIN FILMS
WE CANNOT LOOK AT:
THE PERSONAL CLUTTER
THE PERSISTENCE OF FEELINGS
THE HAND-TOUCH SENSIBILITY
THE DIARISTIC INDULGENCE
THE PAINTERLY MESS
THE DENSE GESTALT
THE PRIMITIVE TECHNIQUES

(I DON'T TAKE THE ADVICE
OF MEN WHO ONLY TALK TO
THEMSELVES)

PAY ATTENTION TO CRITICAL
AND PRACTICAL FILM LANGUAGE
IT EXISTS FOR AND IN ONLY
ONE GENDER

HE SAID YOU CAN DO AS I DO
TAKE ONE CLEAR PROCESS
FOLLOW ITS STRICTEST
IMPLICATIONS INTELLECTUALLY
ESTABLISH A SYSTEM OF
PERMUTATIONS ESTABLISH
THEIR VISUAL SET

I SAID MY FILM IS CONCERNED
WITH DIET AND DIGESTION

VERY WELL HE SAID THEN WHY
THE TRAIN?

THE TRAIN IS DEATH AS THERE
IS DIE IN DIET AND DI IN
DIGESTION

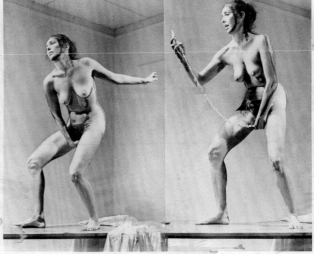

THEN YOU ARE BACK TO METAPHORS
AND MEANINGS MY LOOK HAS NO
MEANING BEYOND THE LOGIC OF
ITS SYSTEMS I HAVE DONE AWAY
WITH EMOTION INTUITION INSPIR-
ATION SPONTANEITY -- AGGRAND-
IZED HABITS WHICH SET ARTISTS
APART FROM ORDINARY PEOPLE --
THOSE UNCLEAN TENDENCIES WHICH
ARE INFLICTED UPON VIEWERS...

IT'S THEN WHEN I WATCH YOUR
FILMS MY MIND WANDERS FREELY
DURING THE HALF HOUR OF
PULSING DOTS I DREAM OF MY
LOVER WRITE A GROCERY LIST
RUMMAGE IN THE TRUNK FOR A
MISSING SWEATER PLAN THE DRAIN-
AGE PIPES FOR THE ROOT CELLAR
-- IT IS PLEASANT NOT TO BE
MANIPULATED

HE PROTESTED YOU ARE UNABLE TO
APPRECIATE THE SYSTEM THE GRID
THE NUMERICAL RATIONAL
PROCEDURES -- THE PYTHAGOREAN
CUES

I SAW MY FAILINGS WERE WORTHY
OF DISMISSAL I'D BE BURIED
ALIVE MY WORKS LOST.........

HE SAID WE CAN BE FRIENDS
EQUALLY THO WE ARE NOT ARTISTS
EQUALLY

I SAID WE CANNOT BE FRIENDS
EQUALLY AND WE CANNOT BE
ARTISTS EQUALLY

HE TOLD ME HE HAD LIVED WITH
A "SCULPTRESS" I ASKED DOES
THAT MAKE ME A FILM-MAKERESS?

OH NO HE SAID WE THINK OF YOU
AS A DANCER

Text from "Kitch's Last Meal"
Super 8 film 1973-76

C.Schneemann

39

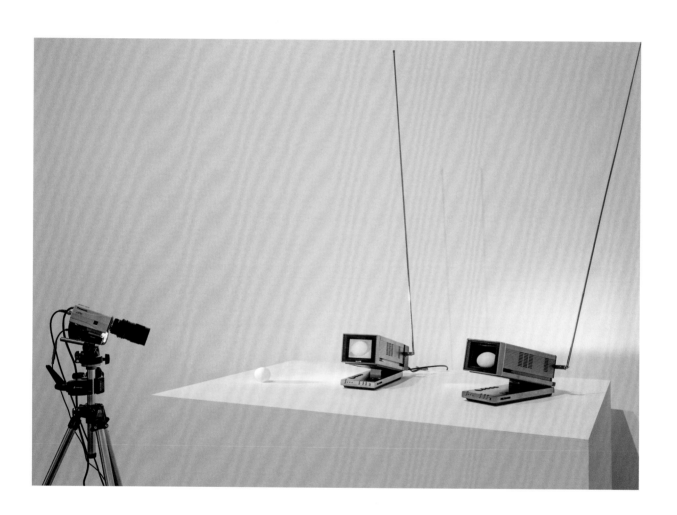

Where did it come from?

Nam June Paik, *Three Eggs,* 1975–82

The 'three eggs' in Nam June Paik's work of the same name present a visual conundrum. Laid out in front of us are an egg, a video camera on a tripod set up to record that egg, a small television monitor screening what appears to be live footage of the egg, and a second television monitor with another egg in place of the screen. If we are to count the three eggs here, one is real, one is a digital image and one is sneakily masquerading as a digital image. It is a deceptively simple work that asks us to question what we see, and how we know what we know.

Nam June Paik is said to be the first artist ever to work with video. Born in Korea and trained as a composer in Japan, he moved to West Germany in the late 1950s and from 1958–63, he got a job working in the electronics studio for a television network, where he worked with the experimental composer Karlheinz Stockhausen. Referring to those years he later said, 'I still did not consider myself a visual artist, but I knew there was something to be done in television and nobody else was doing it, so I said why not make it my job?'[11]

When viewing this work, I'm always astonished by how my eye inevitably seems to be drawn to the footage of the egg on the screen. Even though nothing happens, somehow the televised egg is the most captivating. This effect not only indicates the prevalence of screens within our lives, but also the fact that what we witness on screen is time passing and the possibility inherent within that. There is the feeling that something might happen to the egg, even though logically we know it won't. Of all three eggs, as the immaterial one, the televised egg has the least claim to reality. But who's to say that reality is so important any way, when this egg is the one that gets to have its fifteen minutes of fame?

Tina Keane, *Faded Wallpaper*, 1988
Film stills composite

British artist Tina Keane's *Faded Wallpaper* is
a groundbreaking work of feminist video art
that pays homage to an iconic work of feminist
literature. Published almost a hundred years
prior, in 1892, Charlotte Perkins Gilman's short
story, 'The Yellow Wallpaper', tells the tale of
a woman held in her room. The protagonist,
narrating in the first person, is confined to 'rest'
under the orders of her doctor and husband as
she is suffering from a bout of depression. As the
days go by, with no distractions, she is tormented
by the room's ugly wallpaper and begins to
envisage a woman trapped beneath its oppressive
patterns: a woman who needs to get out.

Keane describes being enthralled by the
imagery in the story, 'all I kept thinking was:
"How can I get an image to come through the
wallpaper?" It really fascinated me.'[12] It took
a long time to evolve the layered effects of
a body lurking, morphing and disappearing
within the flocked wallpaper in the video.
Keane worked with both video, Super 8 and
16mm film, alongside multiple post-production
editing technologies. The artist 'invented the
techniques to show the concept.'[13] Set against an
evocative soundtrack of whispers, ramblings and
ruminations, that include passages from Gilman's
story, the effect is one of slipping into a waking
nightmare, where sound and image gradually
devolve into chaos.

As hands reach out to pick and tear at the
wallpaper, something volatile and unpredictable
is unleashed. Indeed, the purpose of wallpaper
is to cover over imperfections in the walls with
a predictable and repeated pattern. In removing
this veneer of domesticity, the less palatable
suppressed truth is set free. We witness a woman
dissolve the limited roles imposed on her, and
allow another selfhood to emerge.

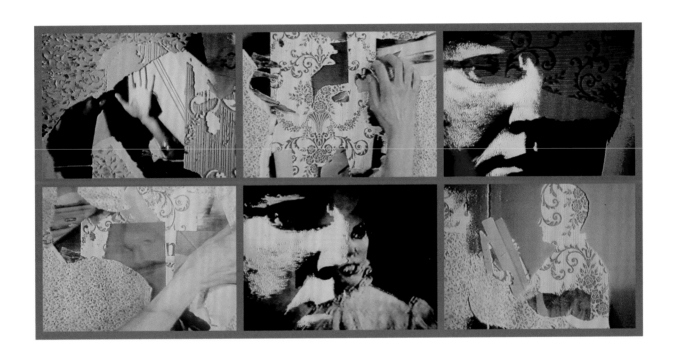

Michael Craig-Martin, *An Oak Tree*, 1973

At first glance, Irish artist Michael Craig-Martin's *An Oak Tree* is a glass of water placed on a small shelf with an accompanying text beside it. As you read the text, you discover that what you are looking at is a full-grown oak tree, with the appearance of a glass of water. Confused? I'm not surprised.

And neither is the artist. The text is structured as a series of very reasonable questions he pre-empts from the viewer, and subsequently answers. And so, 'Haven't you simply called this glass of water an oak tree?' is met with: 'Absolutely not. It's not a glass of water any more. I have changed its actual substance. It would no longer be accurate to call it a glass of water. One could call it anything one wished but that would not alter the fact that it is an oak tree.'

We see this work and we interpret it as a glass of water on a shelf. We may recall a similar one we drank earlier, or we may think of the symbolism of water and associate it with thirst and replenishment, the essential needs of humankind. What Craig-Martin seeks to show is that any such inferences are our own. Here, he demonstrates the difference between the object and the meaning we attach to it. At the same time, he asserts his right as an artist to reject those meanings and circumvent our expectations entirely.

This exercise makes plain the conversation between artist and viewer that occurs via the art object. Who has the final say? Craig-Martin has said, 'belief underlies our whole experience of art: it accounts for why some people are artists and others are not, why some people dismiss works of art others highly praise, and why something we know to be great does not always move us.'[14] So often now, contemporary art presents us with challenging objects that ask us to expand our definitions, and prompt us to question whether we 'believe' these works as art or not. And yet, all these years later, accepting a glass of water as an oak tree may still pose a stretch. Must we obey the authority of the artist? Or can we form our own opinions?

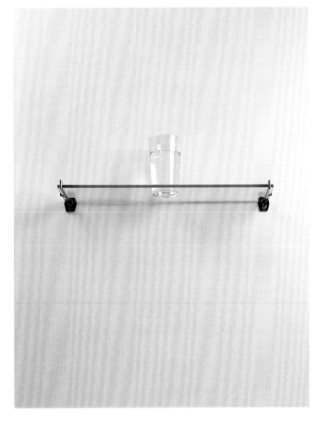

Q: To begin with, could you describe this work?
A: Yes, of course. What I've done is change a glass of water into a full-grown oak tree without altering the accidents of the glass of water.
Q: The accidents?
A: Yes. The colour, feel, weight, size ...
Q: Do you mean that the glass of water is a symbol of an oak tree?
A: No. It's not a symbol. I've changed the physical substance of the glass of water into that of an oak tree.
Q: It looks like a glass of water ...
A: Of course it does. I didn't change its appearance. But it's not a glass of water. It's an oak tree.
Q: Can you prove what you claim to have done?
A: Well, yes and no. I claim to have maintained the physical form of the glass of water and, as you can see, I have. However, as one normally looks for evidence of physical change in terms of altered form, no such proof exists.
Q: Haven't you simply called this glass of water an oak tree?
A: Absolutely not. It is not a glass of water any more. I have changed its actual substance. It would no longer be accurate to call it a glass of water. One could call it anything one wished but that would not alter the fact that it is an oak tree.
Q: Isn't this just a case of the emperor's new clothes?
A: No. With the emperor's new clothes people claimed to see something which wasn't there because they felt they should. I would be very surprised if anyone told me they saw an oak tree.
Q: Was it difficult to effect the change?
A: No effort at all. But it took me years of work before I realized I could do it.
Q: When precisely did the glass of water become an oak tree?
A: When I put water in the glass.
Q: Does this happen every time you fill a glass with water?
A: No, of course not. Only when I intend to change it into an oak tree.

Q: Then intention causes the change?
A: I would say it precipitates the change.
Q: You don't know how you do it?
A: It contradicts what I feel I know about cause and effect.
Q: It seems to me you're claiming to have worked a miracle. Isn't that the case?
A: I'm flattered that you think so.
Q: But aren't you the only person who can do something like this?
A: How could I know?
Q: Could you teach others to do it?
A: No. It's not something one can teach.
Q: Do you consider that changing the glass of water into an oak tree constitutes an artwork?
A: Yes.
Q: What precisely is the artwork? The glass of water?
A: There is no glass of water any more.
Q: The process of change?
A: There is no process involved in the change.
Q: The oak tree?
A: Yes. the oak tree.
Q: But the oak tree only exists in the mind.
A: No. The actual oak tree is physically present but in the form of the glass of water. As the glass of water was a particular glass of water, the oak tree is also particular. To conceive the category 'oak tree' or to picture a particular oak tree is not to understand and experience what appears to be a glass of water as an oak tree. Just as it is imperceivable, it is also inconceivable.
Q: Did the particular oak tree exist somewhere else before it took the form of the glass of water?
A: No. This particular oak tree did not exist previously. I should also point out that it does not and will not ever have any other form but that of a glass of water.
Q: How long will it continue to be an oak tree?
A: Until I change it.

Does it have to
mean something?
Does it have to
mean something?
Does it have to
mean something?
Does it have to
mean something?
Does it have to
mean something?
Does it have to
mean something?
Does it have to
mean something?
**Does it have to
mean something?**

Cuban artist Tania Bruguera asserts the time has come for us to 'put Duchamp's urinal back in the restroom.'[1] In her view, art that involves spectators passively contemplating objects, with no tangible consequence to the outside world, has had its day. Since 2011, she has worked to propagate a form of art called 'Arte Útil', loosely translated as 'Useful Art' or art as a tool. This is a form of art that directly responds to the current crises facing us as a society with practical, beneficial outcomes for those who experience it or use it.

But what does that look like? Arte Útil projects vary widely. Bruguera's long-term art project *Immigrant Movement International*, presented by Creative Time in collaboration with New York's Queens Museum of Art in 2011, took the form of a flexible community space based in the multicultural neighbourhood of Corona, Queens. It responded to the needs of local immigrant communities by offering social services, such as legal aid and some healthcare, campaigning for immigration reform, offering workshops and providing resources for people to come together and exchange ideas.

Initiated by American artist Laurie Jo Reynolds in 2008, another Arte Útil project was the all-volunteer grassroots coalition *Tamms Year Ten*. It united artists and concerned citizens with current and former inmates at the Tamms 'Supermax' Correctional Center in Illinois. Built for sensory deprivation and solitary confinement, Tamms was intended for 'one-year shock treatment', yet ten years after its opening one-third of its prisoners had been incarcerated there for a decade. *Tamms Year Ten* launched a legislative campaign calling for the prison's reform or closure, holding hearings, pulling in human rights monitors such as Amnesty International, and negotiating with the Department of Corrections. Following pressure from the coalition, a plan for reform was introduced in 2008, and the prison was ultimately closed in 2013.

To the untrained eye, this might all look a lot more like activism than art. *Tamms Year Ten* had many different facets: in addition to intensive lobbying, there were more traditional cultural projects such as 'Photo Requests from Solitary', which allowed prisoners in isolation to request an image of anything at all, real or imagined, that a photographer would then produce. But, viewed as a whole, projects like *Tamms Year Ten* use artistic thinking to challenge fields long considered as beyond the realm of art. The premise is that artists can leverage their positions to go through different channels than would ordinarily be available, and make a difference in any number of unusual and creative ways. As Reynolds explained, 'compared to the typical political players, [artists] have the freedom of the outsider: they are in the world, but not of it.'[2]

This approach requires a shift in commonly held understandings of art: the art becomes the social

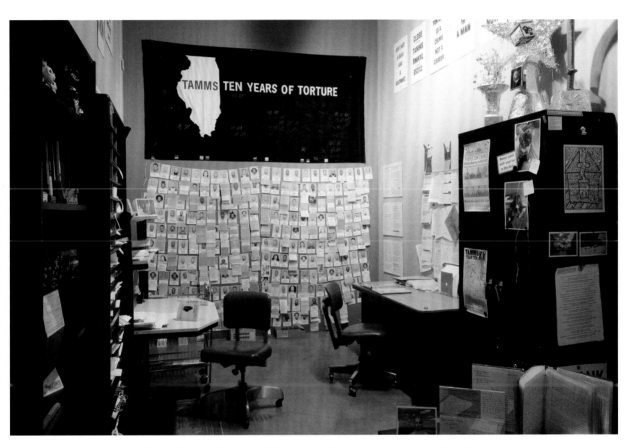

Tamms Year Ten Campaign Office as seen at Santa Monica Museum of Art, 2014

interaction of the community brought together by the artist's intervention. In Bruguera's vision, what the world needs is not 'art that points to a thing. I want art that is the thing.'[3] Rather than making art about a problem, Arte Útil addresses that problem with art that offers a concrete solution. However, there is also a place for art that draws attention to pressing global issues and uses the creative freedoms art affords to encourage an emotional connection in the viewer.

British artist John Akomfrah's six-screen video installation *Purple* is an immersive and moving response to the current climate crisis. It is a work of epic proportions. Blending archival footage with spoken word, an original symphonic musical score and cinematic imagery of awe-inspiring landscapes specially shot in ten different countries, it offers a visual and sonic portrait of the past century. Beginning with the Industrial Revolution, represented through imagery featuring factories, mills and mass employment, *Purple* takes us on a journey through technological advancements, ecological disaster and the cycle of life and death. Scenes of breath-taking natural beauty shot in Alaska, Arctic Greenland, the Tahitian peninsula, the Isle of Skye and the volcanic Marquesas Islands in the South Pacific are tinged with a pointed and looming sense of loss.

Yet, while it evokes a global ecological history, this is also a personal narrative for Akomfrah who grew up in the shadow of the then fully functioning Battersea Power Station in south London. The idea of the individual swept up within the grand narrative is represented repeatedly on screen by lone figures with their backs to the camera, looking out at the landscapes before them as though contemplating their fate. This is a trope used in the nineteenth-century paintings of Caspar David Friedrich to allow the viewer to position themselves in the mind of the painted figure as they consider the sublime power of nature. In *Purple*, this has the effect of presenting us all as individuals, sharing in trying to comprehend a crisis so great in magnitude it can feel impossible to take in.

This sense is mirrored in the cumulative effect of the film's layered visual montage. As you sit surrounded by six large-scale projected streams of imagery, your eye constantly moving between the seductive and captivating scenes shifting and changing on each one, you quickly succumb to a kind of sensory overload. It throws you off-kilter, bypassing a habitual logic in favour of feeling.

Such is the power of this kind of work. In producing an oblique, layered and nuanced picture of the climate emergency in all its complexity, Akomfrah conveys a political message that feels powerfully personal. Without falling into jargon, fear-mongering or hitting you over the head with rhetoric, *Purple* is a call to action. Speaking of his position as an artist, Akomfrah has said, 'I don't have to be an expert to speak about "scientific things". It felt important to try and bring together questions of climate change, with global inequalities which have other histories, colonial and so on. And I don't feel I'm an outsider to any of it.'[4]

After all, the task of the artist is one of imagination. Making art is to reinvent the world in another form, an inherently political act. For many artists, art-making can be understood as a utopian project, reinventing the world you wish to see, whether through practical actions or by allowing space for other worlds to exist tentatively in the mind of the viewer.

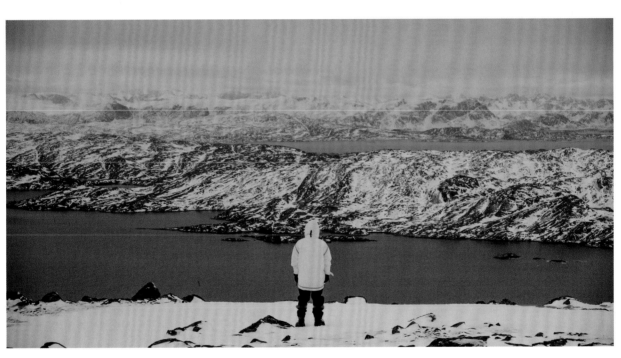

John Akomfrah, Still from *Purple*, 2017. Six-channel video installation with 15.1 surround sound, 62 minutes

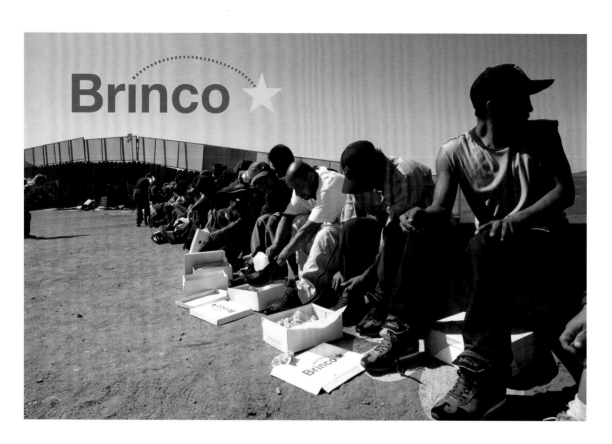

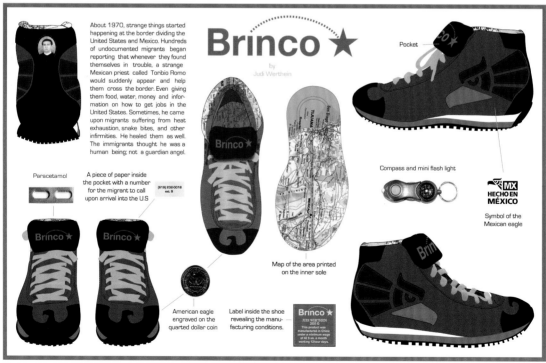

About 1970, strange things started happening at the border dividing the United States and Mexico. Hundreds of undocumented migrants began reporting that whenever they found themselves in trouble, a strange Mexican priest called Toribio Romo would suddenly appear and help them cross the border. Even giving them food, water, money and information on how to get jobs in the United States. Sometimes, he came upon migrants suffering from heat exhaustion, snake bites, and other infirmities. He healed them as well. The immigrants thought he was a human being; not a guardian angel.

Brinco ★
by
Judi Werthein

Pocket

Paracetamol

A piece of paper inside the pocket with a number for the migrant to call upon arrival into the U.S

(619) 232-0015 ext. 9

Compass and mini flash light

MX
HECHO EN
MÉXICO

Symbol of the Mexican eagle

American eagle engraved on the quarted dollar coin

Label inside the shoe revealing the manu-facturing conditions.

Map of the area printed on the inner sole

Brinco ★
JUDI WERTHEIN
2005 ©
This product was manufactured in China under a minimum wage of 42 $ us. a month working 12hour days.

Judi Werthein, *Brinco*, 2005

'My interest is to relate to the masses, not to the small circle of the art world,' states Argentinian artist, Judi Werthein.[5] That is certainly true of her 2005 work *Brinco*, a trainer designed for Mexican migrants crossing the US border illegally.

Numbers vary, but every year hundreds of thousands of migrants attempt to make the dangerous border-crossing – a journey known colloquially in Spanish as '*brinco*' ('leap') – most often on foot. The *Brinco* shoe is shaped like a small boot to protect and support weary ankles in rough terrain. The shoe's removable insole shows the most frequented illegal routes from Tijuana into San Diego. There is an embedded flashlight, a painkiller and a secret pocket for money. Its design wryly incorporates the national symbol of the eagle common to both countries. Adorning the top of the heel is an image of Toribio Romo González, the patron saint of Mexican migrants.

Werthein distributed the trainers for free to migrants about to embark on the crossing in Tijuana, but she also sold them just across the border in San Diego, as limited edition art objects at a high-end sneaker store, with a price tag over 200 US dollars. Part of the proceeds were donated to a Tijuana shelter helping migrants in need. The project generated a storm of controversy; the artist was accused by some of aiding illegal migration, and even received threats and hate mail.

Brinco brought together two demographics that have little in common – illegal migrants and wealthy art and sneaker collectors – highlighting the starkly different realities in which the trainers are used. Moreover, the project's premise is further complicated by the fact that the shoes are produced cheaply in China. In this context, the shoe stands as a symbol of a global web of oppression, inequality and injustice.

Meschac Gaba, *Marriage Room* from the series
***Museum of Contemporary African Art*, 1997–2002**
Installation view, Tate Modern, 2013

Until all too recently, in Europe and North America, art from Africa could only be found within ethnographic museum displays. Contemporary African artistic production did not have a place in Western art museums, nor were there any dedicated museums of contemporary African Art in Africa. For Beninese contemporary artist, Meschac Gaba, this was a bleak state of affairs: there was no museum to show his work – so he decided to make his own.

By titling his series *Museum of Contemporary African Art*, Gaba foregrounded the fact that no such institution existed. In addition to being the artist, he also took on the roles of curator, director and owner at his new museum. Developed over five years from 1997 to 2002, the project comprised twelve large-scale interlinked installations, each one representing a different room within his museum. These various installations were displayed as temporary exhibitions within existing museums normally reserved for art of Western origins, allowing the artist to redefine these museums as his own. Each section outlined an area that Gaba believed central to a museum's mission: many involved social interaction or informal presentations of objects from everyday life.

In the *Architecture Room*, visitors could imagine their own museums using wooden building blocks. In the *Museum Restaurant*, fellow artists were invited to prepare and host meals for gallery-goers, served on communal tables adorned with colourful plastic tablecloths.

Perhaps the most extraordinary room of all was the *Marriage Room*. In October 2000, Gaba married curator Alexandra van Dongen as part of a group exhibition at the Stedelijk Museum in Amsterdam. The subsequent *Marriage Room* presents a display of wedding photos, a video of the ceremony, the marriage certificate, the bride's dress and shoes, and guest book, along with a variety of wedding gifts. To see an event as personal as the artist's wedding formulated into an exhibition calls into question the kinds of events and objects deemed 'museum-worthy'. As today's museums look to serve audiences in more inclusive, engaging and meaningful ways, more than two decades ago Gaba offered us a radical and prescient rethinking of what a museum could be. Far from a tired repository, his museum is a meeting place, a space for creativity and play, and a site for celebrating and sharing the most significant moments in life.

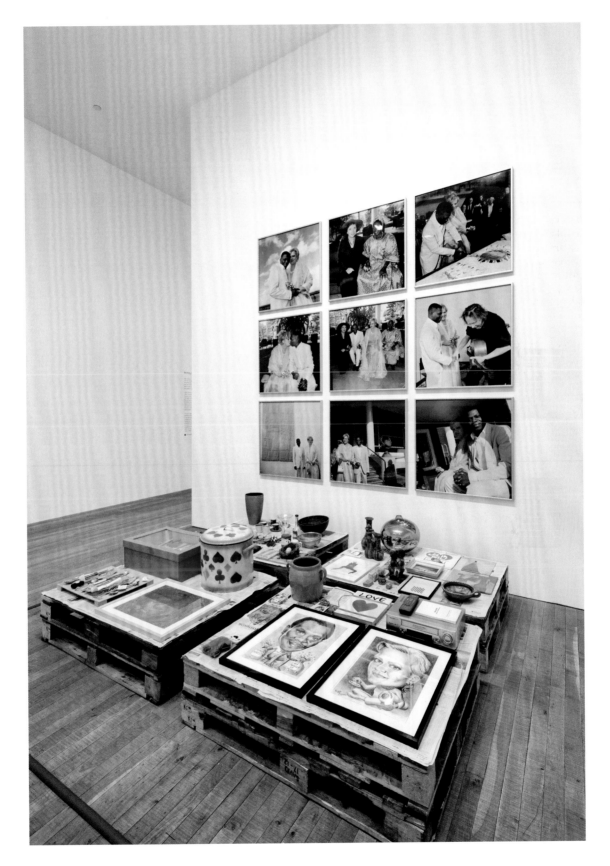

Does it have to mean something?

Zach Blas, *Facial Weaponization Suite: Fag Face Mask – October 20, 2012*, Los Angeles, CA, 2012

In recent years, facial recognition technologies have slowly crept into our daily lives, from e-passport gates at the airport to unlocking your phone simply by looking at it. But these time-saving conveniences are accompanied by far-reaching implications for civil liberties in an era of mass surveillance and 'big data', of targeted marketing and state control.

In tandem, many scientific studies have emerged seeking to decipher and interpret 'facial data'. Artist Zach Blas's *Fag Face Mask* responds in particular to research claiming that sexual orientation can be determined through rapid facial analysis. Such a conceit raises concerns around privacy and the need for such apparatus of inclusion and exclusion, but also the fixedness of sexuality and identity. The very premise plays into established homophobic ideas of what gayness looks like.

The *Fag Face Mask* is an act of resistance. During a workshop in Los Angeles in 2012, Blas collected 'the biometric data of many queer men's faces', and aggregated them into one composite form, creating a blob-like pink mask.[6] The resulting mask does not register on facial-recognition software. In the tradition of protest and activist groups such as Anonymous and Pussy Riot, the mask hides the user's face and protects their identity, while simultaneously drawing attention to the wearer and identifying them as a member of a particular community. For Blas, this act of 'defacement' is ultimately a queer practice, in that it resists normative binaries by escaping the constraints of legal identification into something that is unquantifiable, weird, extraordinary, and ultimately: free.

Jenny Holzer, *Inflammatory Essays*, 1979–82

'REJOICE! OUR TIMES ARE INTOLERABLE,' begins
one of Jenny Holzer's famous *Inflammatory
Essays*. 'RUIN YOUR FUCKING SELF BEFORE
THEY DO,' storms another. Each 'essay' is set
in bold italics, all-caps – effectively shouting
off the page – and printed on brightly coloured
paper. Although each of the thirty-one texts
approaches a different topic, they share a caustic
and assertive language and a strict format of
precisely one hundred words running across
twenty lines. The tone is urgent and fanatical, that
of a religious fundamentalist, unhinged dictator
or zealous radical. As the title suggests, these
are powerful 'inflammatory' essays addressing
pressing issues of consumerism, violence,
intolerance and abuses of power.

Holzer began this body of work while a
student at the Whitney Museum of American
Art's prestigious independent study programme,
where her assigned reading list included texts
by Lenin, Trotsky and Hitler, among others.
Although the *Inflammatory Essays* were first
published in a 1979 artist's book entitled *Black
Book Posters*, they found their true form when
Holzer began fly-posting them across New York
City. She commented to an early critic, 'They're
not appropriate for any other form. They're really
hot, flaming, nasty things, and they need to have
an underground format for immediacy.'[7]

It was important to Holzer that these works
were stumbled across in the course of daily lives,
and not read immediately as art. This allowed
them to reach a broader, less homogeneous
audience, and imbued the texts with a disruptive,
perplexing quality that lingered in the mind. It
is impossible to tell if any of the views in these
texts are Holzer's own and her personal opinions
are beside the point. Disconnected from sincerity
and unsubstantiated by fact, these rousing verses
provide a call to action without direction.

Decades later, these essays are often
displayed together on the walls of museums.
Predating the internet, this battery of contradictory
messages now takes on the quality of an
unnervingly prophetic harbinger, as searing and
prescient among today's 'alternative facts' as ever.

DESTROY SUPERABUNDANCE. STARVE THE FLESH, SHAVE THE HAIR, EXPOSE THE BONE, CLARIFY THE MIND, DEFINE THE WILL, RESTRAIN THE SENSES, LEAVE THE FAMILY, FLEE THE CHURCH, KILL THE VERMIN, VOMIT THE HEART, FORGET THE DEAD. LIMIT TIME, FORGO AMUSEMENT, DENY NATURE, REJECT ACQUAINTANCES, DISCARD OBJECTS, FORGET TRUTHS, DISSECT MYTH, STOP MOTION, BLOCK IMPULSE, CHOKE SOBS, SWALLOW CHATTER. SCORN JOY, SCORN TOUCH, SCORN TRAGEDY, SCORN LIBERTY, SCORN CONSTANCY, SCORN HOPE, SCORN EXALTATION, SCORN REPRODUCTION, SCORN VARIETY, SCORN EMBELLISHMENT, SCORN RELEASE, SCORN REST, SCORN SWEETNESS, SCORN LIGHT. IT'S A QUESTION OF FORM AS MUCH AS FUNCTION. IT IS A MATTER OF REVULSION.

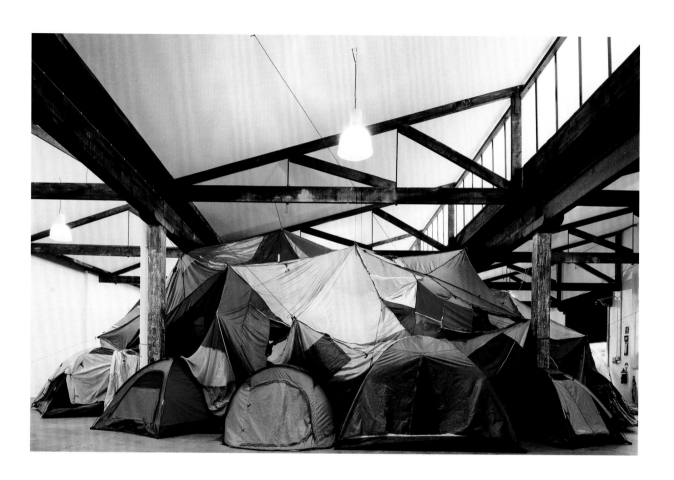

Does it have to mean something?

Australian artist Keg de Souza's work *We Built This City* lists as its medium, 'tents, tarps, hessian sacks, piping, plaid laundry bags, various found and recycled materials, dialogue and tour programme.' The dialogue that it fosters and the programming it enables are just as integral to its being as its material elements.

Built as part of the 2016 Sydney Biennale art festival, *We Built This City* was housed in an empty building in the inner-city area of Redfern. The neighbourhood has historically been home to a largely working-class and Indigenous community, but has seen much change in recent years through gentrification, with many of these residents displaced as a result. *We Built This City* was designed as a space for the *Redfern School of Displacement*, a temporary platform for cultivating local knowledge and stimulating conversation around social justice and the politics of displacement. The site – on Aboriginal land, belonging to the Gadigal People of the Eora Nation – is fundamental to the project, as is thinking through what it means to be on Indigenous land. Through talks, discussions, performances and tours of the surrounding area, the School sought to generate dialogue around issues such as dispossession through enforced adoption of non-native language, homelessness and forms of displacement caused by gentrification, climate change or conflict, on both a local and global scale.

The work was informed by de Souza's training in architecture and her experiences of squatting and participating in community projects. De Souza explains that 'it is in these cracks that we also see alternatives created. Tent cities often allow for spaces of informal economies, self-management, self-education, direct democracy, resourcefulness and tolerance, embodying sites of resilience and resistance.'[8] The *Redfern School of Displacement* sought to create space for marginalised voices to be heard, and placed communities' lived experiences at the centre of proceedings in an effort to build a fairer future.

Does it have to mean something?

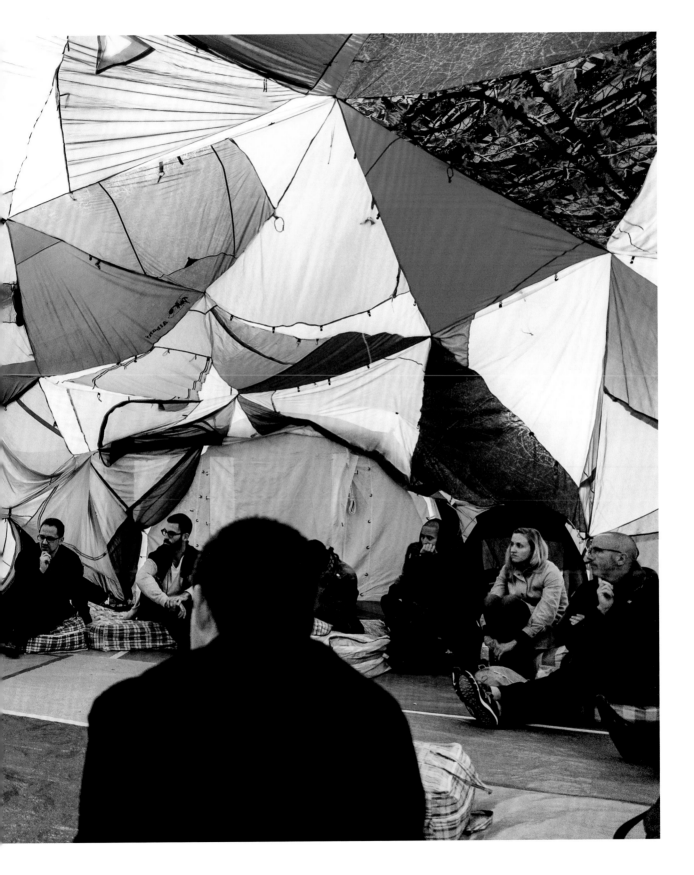

Alexandra Pirici, *Soft Power*, 2014

Romanian artist Alexandra Pirici is known for her performances that stage 'sculptural' interventions at historic public monuments. Drawn to these symbols of grandeur that seek to venerate individual achievements and glorify the past, Pirici describes her work as 'a way to interfere with the assigned meaning of these constructions in hard, immutable materials; it is a way of engaging with and also re-performing history, of making it fluid and produced anew with living bodies.'[9]

For her *Soft Power* series, for example, the artist worked with a group of plain-clothes performers to respond to three of the most iconic monuments in Saint Petersburg: the Bronze Horseman, Catherine the Great, and Vladimir Lenin at the Finland Station. At the statue of Lenin, they formed a three-tiered human pyramid replicating the figure on his pedestal for a moment, before dispersing. Importantly, it was not a precise imitation: a female performer was chosen to impersonate Lenin, and her pose mirrors his, rather than miming it exactly.

The image of the two constructions side-by-side is faintly ridiculous. This is thanks in part to the circus acrobatics involved, but more because the real human feat taking place alongside this gigantic bronze shows it to be a hollow idol. And yet, its power is closely protected by the state. Pirici's responses may seem playful, but they are politically charged, and even dangerous. Sunbathers performing as part of another intervention beside the Bronze Horseman were asked to move by police and reportedly threatened with fifteen days' imprisonment.

Why is the sanctity of public monuments so closely guarded? Although we are often so accustomed to seeing them, we may barely pay them any mind. Yet public monuments act as symbols of historic narratives that uphold governing systems of power. By overlooking them, do we tacitly accept those systems? With her parallel 'human' monument, Pirici invites us to consider an alternative structure: a nimble and collaborative one that operates in the here and now.

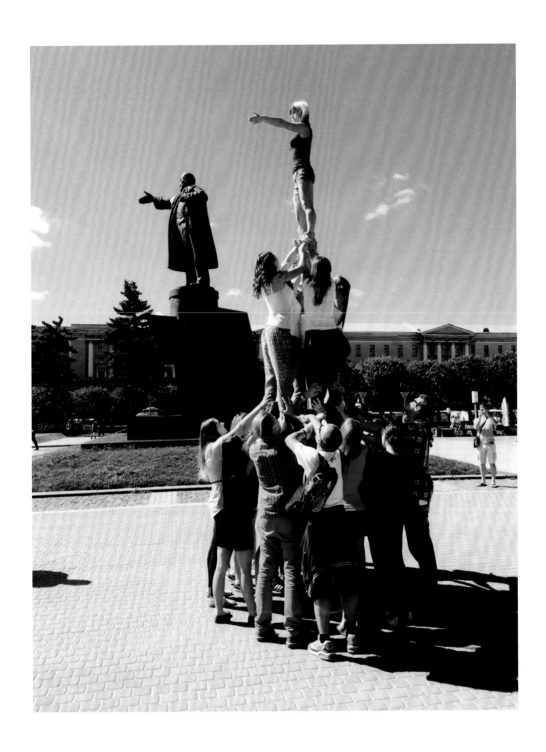

What about
how it feels?
**What about
how it feels?**
What about
how it feels?

What about
how it feels?

What about
how it feels?
What about
how it feels?
What about
how it feels?

Writing after viewing a classical sculpture in 1795, the German poet Johann Wolfgang von Goethe describes the sensation of 'seeing with vision that feels, feeling with fingers that see'.[1] Encountering an artwork can be much more than just a visual experience. Often it is a tremendously tactile one, too – even if we are not permitted to touch.

Brazilian artist Anna Maria Maiolino's installation *Continuous* presents hundreds of pieces of clay moulded in various ways, arranged on tables, shelves, a pallet and fixed to chicken wire skirting the wall. The clay is organised into sections and in each it takes on a different hand-shaped form. On one table, the clay is rolled neatly into balls of the same size; on the pallet it is formed into long sausages, piled and folded over one another; along the wall, little doughnut shapes spread like flowers on a trellis, each one bearing the imprint of the fingers and thumbs used to create their indentations. It's striking to see so much clay and so many repeated forms spread out in one space. But the soft clay is also humble and familiar, recalling muddy earth and childhood experiments in plasticine, or perhaps adult experiments in breadmaking.

As Maiolino describes, the various forms contain the 'memory of the gestures that originated them: kneading, rolling, tearing.'[2] Although we are presented with a finished artwork, the unfired clay evokes the process of its making, what the artist calls 'the work of happy hands'.[3] While each form is repeated, each piece maintains the distinctive qualities of its making. This difference within repetition is a long-held source of interest and wonder for Maiolino. She elaborates, 'I realized that the action of the hands is never the same. Its variation is directly related to the body's energy. That such physical gestures produce differences as they're repeated might seem obvious to some, but I found the realization liberating!'[4]

Indulging in the process allowed her to let go of the pressures of an artistic vision or master plan. The final configuration of these works is unplanned, and evolves as they are made, ultimately a synthesis between the will of the artist, the nature of the space, and the inherent qualities of the material. She has said, 'The concept of seriality helped me realize that I don't need to create something new at all times; the process of manual repetition is itself revealing.'[5]

Once complete, the passage of time is visible in the way the raw clay dries, darkens and cracks over the course of the exhibition. And as the clay is not fired, it can be recycled at the end of the show. Therefore, these works encapsulate a huge investment of time and energy within their making, exist briefly for exhibition, and then disappear, absorbed back into the art ecosystem. They are markers of 'the history of humanity's work'.[6] Forming earthenware from clay is

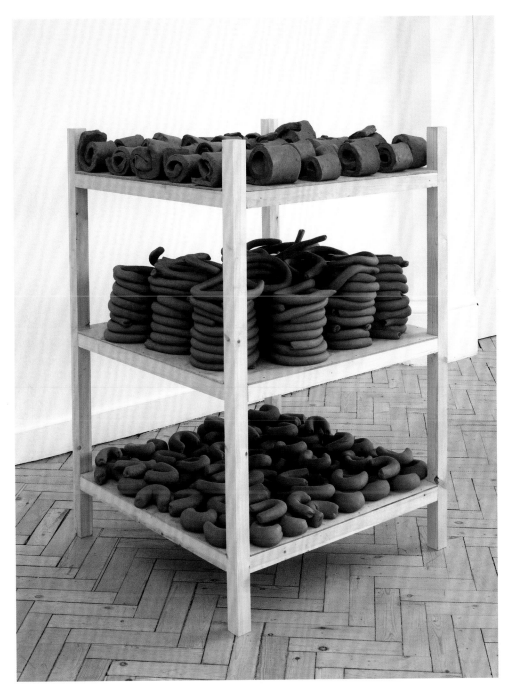

Anna Maria Maiolino, *Continuous*, installation view at Camden Art Centre, London, 2010

What about how it feels?

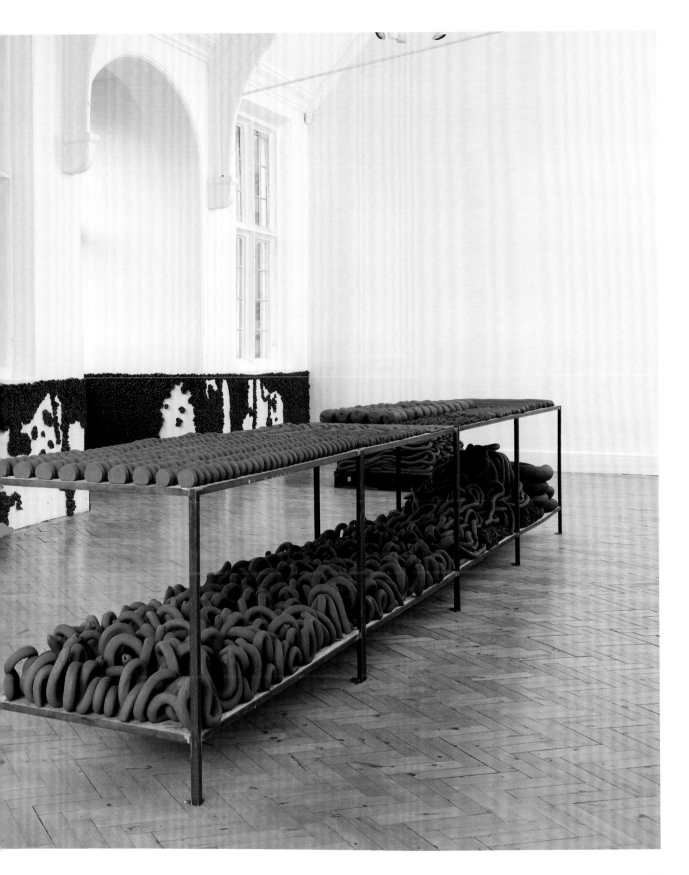

Olafur Eliasson and Ma Yansong, *Feelings are Facts*, 2010

What about how it feels?

a labour that dates back to prehistoric times, while the acts of kneading and rolling recall generations of the invisible efforts of women preparing food in the home. Maiolino's actions carry within them the legacy of many and encapsulate the processes through which humanity has evolved to survive.

This notion of a certain kind of wisdom within our bodies is one that comes up time and again within art-making. Whether it is understood as primal knowledge accumulated over generations, a channel to the divine, or simply the legacy of our lived experience, many artists consider a corporal intuition integral to the way they work with materials, and the creative process more broadly. Danish-Icelandic artist Olafur Eliasson, for example, seeks to awaken this same awareness within his audiences.

Collaborating with Chinese architect Ma Yansong, Eliasson presented the expansive installation *Feelings are Facts* at Ullens Center for Contemporary Art in Beijing in 2010. Within moments of entering the space, visitors are engulfed in a velvety cloud of pure colour. It is both a magnificent and terrifying experience. A system of artificial fog and coloured fluorescent lighting creates a surprisingly spectacular effect. The illuminations are assembled in fields of red, green and blue, which create the optical effect of blended hues of cyan, magenta and yellow as you traverse between them. The fog is so thick that it's hard to see any distance in front of you; the colours feel almost palpable. It's breath-taking!

But being enveloped in a brilliant cloud at an art gallery is also very unsettling. Almost as soon as you enter, you lose sight of where you came in. In fact, Eliasson and Ma's intention was to make the space more disorienting. An incline was added to the floor and the ceiling was lowered. In the heavy atmosphere and the bright lights, it was already very difficult to see where you were going and avoid the risk of walking into a wall. With the ramp, it was also necessary to constantly renegotiate your balance. To navigate the work, you cannot rely on your vision, and your other senses become heightened as you use the sounds of other visitors, careful steps, and your outstretched hands to feel your way.

Feelings are Facts presents a challenge to step out of familiar patterns of viewing and rely on the spatial intelligence of the body to experience full immersion into the work. This awakening of our sensory intuition combined with the emotive effects of colour is powerful. Whether you feel as though you are floating on a cloud or oppressed by the dense atmosphere, the work is a physical experience. Ultimately, Eliasson and Ma present coloured light and water vapour, yet the work is so much more. In inviting us to transcend the everyday, the artists seek to enliven the latent sense of possibility we each carry within ourselves. If we can hold onto that and harness it, imagine all the things we might be able to create and achieve. Analysis and intellect can come later; *Feelings are Facts* encourages an intuitive response. As the title suggests, although we cannot quantify feelings: they are real and they have value.

Phyllida Barlow, *untitled: upturnedhouse2, 2012*, 2012

British artist Phyllida Barlow's large-scale sculpture, *untitled: upturnedhouse2, 2012* looks like it might topple over at any minute. Exactly 5m (16½ft) in height and almost the same in width, it's an imposing presence but somehow it doesn't feel monumental. This is in part because it is made from the cheap, readily available stuff of wood, polyurethane foam and cement. Across her sculptural practice, Barlow prefers to work with what she calls 'crap' materials. Similarly, rather than using traditional processes such as carving or welding, she prefers a working method that is more about accumulation and arrangement. She traces these preferences back to when she first started working with clay in art school. She explains, 'It gave me this ability to change things very quickly and accumulate, add and add and add and then take away: a constant ebb and flow between adding and removing.'[7]

This cumulative way of working is apparent in the ramshackle appearance of *untitled: upturnedhouse2, 2012*, with its piling-on of multiple coloured panels. It possesses a distinctly hand-made quality, the hand-crafted mouldings at the edges of each panel clearly visible. Far from a house as a solid structure representing stability, *untitled: upturnedhouse2, 2012* is turned on its head, restless and unpredictable. Defining elements of the house remain in the fragment of a stairway at its top, and what may be a mezzanine jutting out from its side, while the panels take on the quality of windows. But the building's function is completely voided: even if it wasn't upside down, the absence of a door makes it impossible to enter. It's a work that breaks all the rules, but it does it with charm and playful irreverence.

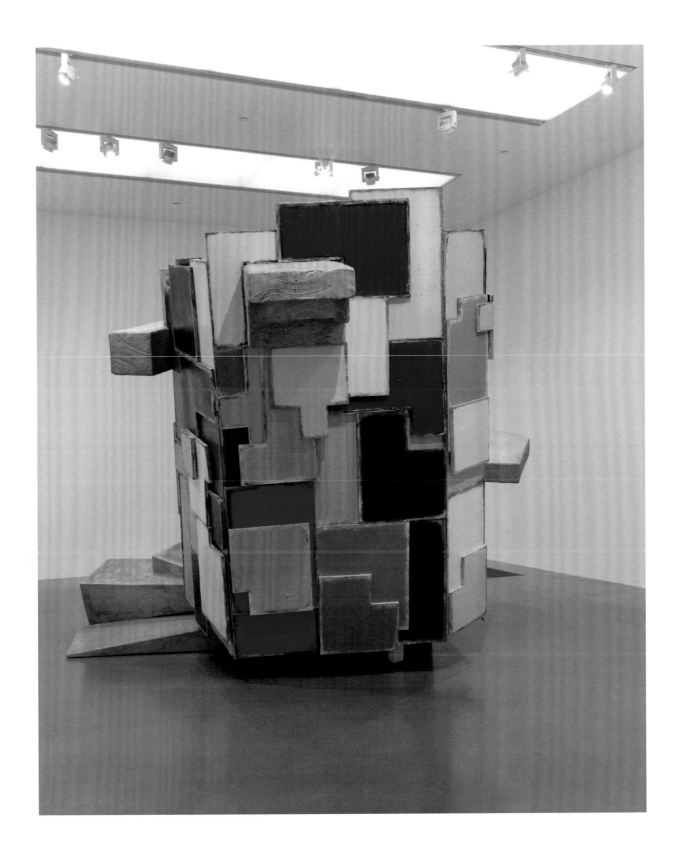

Olia Lialina, screenshot from *Summer*, 2013

Summer is a time to leave your troubles behind, to go outdoors and soak up the sun or, following the lead of Russian artist Olia Lialina, to swing on a playground swing without care. In her online work *Summer*, the artist is shown against a blue gradient that mimics a summer sky, swinging back and forth with joyful abandon. It's a simple looped animation, describing a simple pleasure – or so it seems.

Although this may recall the kind of whimsical gif you might be sent over WhatsApp or Instagram, it is more complex than that. The clue is that the chains of the swing hang from the address bar in your browser. As it happens, each frame of the animation is located on a different artist's website so, to produce the movement of the swing, your browser must flick through more than twenty websites in quick succession. If you look at the address bar, you will see the URL rapidly jumping through different sites, each ending with the extension '/olia/summer'. The animation does not exist in any one place; it can only happen through the journey from one website to the next.

Lialina was one of the first artists to make work on the internet in the 1990s, when webpages were slow to load and glitchy. In some ways, this work is a tribute to the structure of the internet. As an artist working in ceramics might delight in the medium of clay, Lialina here revels in the mechanics of digital communication. If even one link is down, the work is broken. It reminds us that the internet is not a fixed place, but a loose web connected across different servers. In the motion of one swing back and forth, we can visit twenty-five artists' studios and travel the world.

The image shows a browser window with the URL https://www.jaka.org/olia/summer/

Rudolf Stingel, *Untitled*, 1993

Please do not touch: that's the rule. We all know it by now. So when you are not only allowed but also encouraged to touch a work like *Untitled* by Italian artist Rudolf Stingel, it feels positively dizzying. *Untitled* is a large wall covered floor-to-ceiling in custom orange carpeting. The pile is thick, which means if you run your finger through it against the grain, it leaves a mark. It is possible to mould your own drawings and messages into its surface, and many people do. In this sense, the audience is integral to completing the work and the artist has given up control. Instead, Stingel offers up a platform for self-expression.

Untitled also tempts the senses. The combined effect of luscious colour and texture is inviting – an effect sometimes achieved in abstract painting – but here you are permitted to indulge your desire to touch.

Indeed, the medium is an important aspect here. Stingel trained in painting and his carpet-based works emerged out of the concerns he explored on the canvas. What if a painting was not just something that hung on a wall, what if it *was* the wall? Many abstract expressionist painters of the 1950s worked on increasingly large-scale canvases so that the colours represented would engulf the viewer and fill their field of vision. Here, Stingel uses the unlikely material of carpet to achieve that same goal, but on an even bigger scale (the version at Tate Modern is around 5m tall by 9m wide/16½ by 29½ ft; dimensions vary). It is a simple piece: this is commercially manufactured carpet, albeit made according to the artist's instruction, but what it encourages in visitors is amazing. Granted, most people just write their names, or 'hello', but *Untitled* encourages touch, creativity and self-expression in a place where we are taught to obey the rules and behave – and that is truly liberating.

What about how it feels?

Anish Kapoor, *As if to Celebrate, I Discovered a Mountain Blooming with Red Flowers*, 1981

Anish Kapoor's sculpture, *As if to Celebrate, I Discovered a Mountain Blooming with Red Flowers*, astounds with its rich colours and sensuous forms. An arrangement of three elements is laid out in a loose cluster on the floor. Red 'mountains' rise up out of the ground, other rounded red forms appear almost to wobble in place, while a yellow boat-like shape suggests a directional travel between the two. The interplay between these individual elements makes the sculpture more than the sum of its parts. Placed in this careful 3-2-1 sequence, the objects together evoke a charge reminiscent of the arrangement of ritual objects on an altar or shrine.

However, it is the richly coloured surfaces of these pieces that truly delight. As Kapoor describes, 'they seem to be a source of light.'[8] This loaded visual effect of dense colour is combined with a soft, powdery surface quality that is so tactile it is almost delicious. There is no trace of the artist's hand in their construction: it is almost as though they have been poured entirely out of pigment, or are primordial forms that have always existed just so. In a 1990 interview, Kapoor explained that with these early works, he was looking to 'arrive at something which was as if unmade, as if self-manifest, as if there by its own volition.'[9]

Importantly though, it would be a mistake to understand this sculpture as an abstract arrangement alone. With these exuberant colourful forms, Kapoor invites us to share in his joy in celebration, and surprise in discovery.

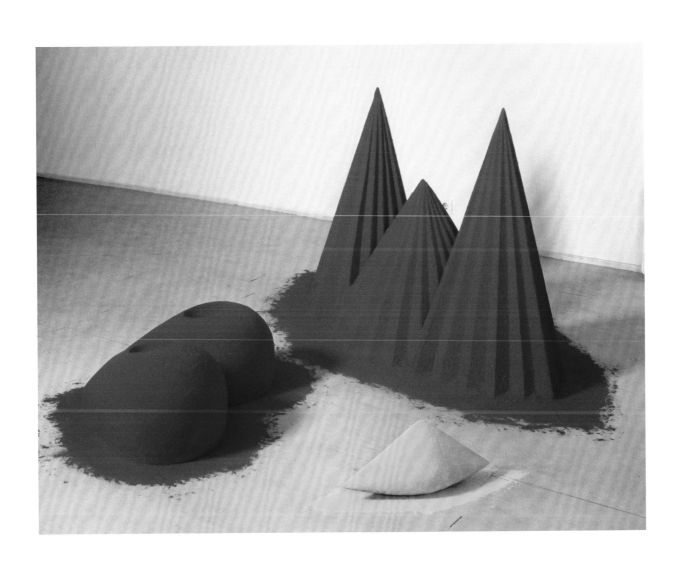

What about how it feels?

Melanie Manchot, stills from *Cadence*, 2018

It starts with a white screen. A few seconds into the video, something emerges into the frame. It takes a little while to figure out what it is, but soon you realise you are watching from above as a black horse is led along by its handler. Its hoofprints reveal that the white expanse is a brilliant and immaculate blanket of fresh snow. The horse's handler wears white and is barely visible against the snowy ground. Upon reaching the centre of the frame, the handler stays in place and begins guiding the horse in a series of concentric circles around them. The horse's hoofprints create a kind of sketch when viewed from this elevated vantage point. The pair leave the setting the way they came, a crisp drawing etched into the ground, recalling a dandelion seedhead.

Unfolding in complete silence, what happens over the four-minute running time is beautiful in its simplicity. German artist Melanie Manchot's looping video was shot in the Swiss mountain village of Engelberg, a place she has visited almost every year for the past twenty-five years, and sought to represent through a variety of works since 2010. In a happy coincidence, the title of this piece, *Cadence*, is the name of the horse but it also suggests the modulation of a voice or musical phrasing. These are surprising associations for a silent film and in this context, evoke the rhythmic footsteps of the horse and intimate the gentle sounds to which we are not privy. The film provokes other senses too: one imagines the feeling of stepping into fresh snow, the smell and taste of the crisp winter air, and the cold against your cheeks. It's a mysterious scene: did the artist happen upon a horse-training exercise, or was this staged for us? Nonetheless, for a few brief moments, we are suspended in a still, white space watching this careful process unfold.

Does it have to
be so serious?
Does it have to
be so serious?
Does it have to
be so serious?
**Does it have to
be so serious?**
Does it have to
be so serious?
Does it have to
be so serious?
Does it have to
be so serious?

Rose Finn-Kelcey, *The Restless Image:
a discrepancy between the felt position and the seen position*, 1975

Often, we think of contemporary art as terribly serious. For many of us, it brings to mind high-concept minimalist interventions, spruced up in unintelligible language and mired in dense theoretical frameworks. That sharp discomfort and sense of foolishness, when you can't tell if a fire extinguisher is an artwork or not, is still the overriding association for many. Yet, it doesn't all have to be intellectual discussion and faux beard-scratching. There is space for joy in contemporary art! Humour, even, and dare I say it – fun!

British artist Rose Finn-Kelcey's black-and-white photograph of a woman doing a handstand on the beach captures what looks to be a moment of pure joy and spontaneity. On a deserted beach, save for one lone figure in the distance, the woman is poised mid-handstand, her pleated skirt falling forwards to cover her face and torso. It's the quintessential image of care-free abandon, an expression of delight in the setting, in one's own physicality, and in the pleasures of being alive. But, when you look closer, the hidden figure takes on the quality of an inverted humanoid creature: all legs and arms and textured fabric. It is the liberating act of the handstand that causes the skirt to billow and fall, but in so doing, the skirt envelopes and traps the protagonist's frame within it.

The woman in the photograph is the artist herself. Finn-Kelcey modelled the composition after a snapshot of her mother in her youth. Seeking to evoke a similar sense of lightness and freedom, she re-staged the image on the beach at Dungeness, Kent, which she used to visit with her family as a child. Surprisingly, for an image that seems so natural and impromptu, it is the product of a carefully managed re-enactment. The handstand was repeated over and over, with the skirt's pleats deliberately fanned out for effect. *The Restless Image* depicts an uncertain and fleeting state, a painstakingly controlled balancing act caught on camera.

Significantly, the work's subtitle – *a discrepancy between the felt position and the seen position* – reveals a further layer of meaning. In part, this refers to the experience of being both artist and subject at the same time. Speaking of her performance work during that period, Finn-Kelcey explained, 'At the time, I wanted to be both inside the work and yet, as it unfolded, to also be an objective viewer'.[1] In reconstructing the scene, the work can be seen as Finn-Kelcey attempting to understand something of what her mother felt, beyond what could be observed by looking at the original photograph. But it is also a reference to the gulf that often exists between appearance and reality, between what we present publicly and what is felt privately.

While a sense of light-heartedness suffuses Finn-Kelcey's image, it should not be mistaken for any lack

of seriousness in its making or ambition. Poignantly conveying and instilling the essential human emotion of joy is a difficult feat to get right. Humour can be another avenue to joy. Contemporary art can be very funny: comedy can be a tool for gaining people's attention and putting them at ease long enough to deliver a searing punchline.

As part of his presentation for the Dakar Biennial in Senegal in 2018, Moroccan artist Younes Baba-Ali staged *Daily Wrestling*. As the country's national sport, traditional folk wrestling plays a big part in Senegalese culture. Professional wrestlers are local heroes, and the cash prizes for the winners of wrestling competitions offer a tantalising route out of poverty in a country where the average income is three US dollars a day. Against this backdrop, Baba-Ali worked with the local community to put on a wrestling match with a difference. Rather than sparring off against other wrestlers, the wrestlers in Baba-Ali's match competed against everyday objects drawn from their daily struggles. And so, carpenter Boy Toucouleur squares off against his work table, security guard Saloum Saloum II takes on the bed that he has difficulty waking up from in time for work, vendor Khoyane goes up against jerrycans of cooking oil and fisherman Mbengue Mboro fights his net.

The match is staged in all seriousness (which adds to the absurdity of the premise), with all the elements of a real wrestling contest. Flyers were handed out and posters were put up around the city, and t-shirts were even printed. In the video footage from the event the excitement is palpable. As the crowds cheer and children dance, each of the wrestlers take part in preparatory rituals to bring them good luck, rubbing themselves with lotions and oils in the hopes of increasing their chances. The whistle blows and the crowd erupts in a frenzy as Boy Toucouleur lands the first punch against the table. It can't be easy to wage war against some cooking oil, but Khoyane really goes for it, playing to the crowd by fiercely emptying the cans over her face, jumping and stamping on them.

The scene is bizarre and surreal, but also cathartic. Fundamental to satire is the use of humour as a vehicle for conveying harsh truths. Throughout the history of art in the twentieth century, we see absurdity used as a way of highlighting contradictions within widely held understandings of art. Behind the thrill of victory in wrestling inanimate objects is an incisive commentary on the realities of daily existence trying to make ends meet in Senegal. The real challenges are those faced in trying to make a living.

Younes Baba-Ali, still from the performance of *Daily Wrestling*, 2018;
overleaf: stills from the promotional trailer

Does it have to be so serious?

Carsten Höller, *Test Site*, 2006
Installation view, Tate Modern, 2006

'It is impossible to travel down a slide without smiling,' says German artist Carsten Höller.[2] If you were a visitor to Tate Modern in 2006, you would have been able to test out that theory. Five tubular, spiralling metal slides were installed in the Turbine Hall, allowing visitors an alternative route from the gallery's upper levels to the ground floor. Not for the faint-hearted, the largest slide from Level 5 was 58m (190ft) long and covered a 27-m (88½-ft) drop. Though these gleaming sculptural chutes present a spectacle in themselves, the artist is more interested in the slide as a vehicle for experience, one that allows for an emotional state described by the French writer Roger Caillois as 'a kind of voluptuous panic upon an otherwise lucid mind'.[3]

Titled *Test Site*, the installation was intended as an experiment in a number of ways. Höller was motivated by the question of whether the cumulative effect of sliding daily could affect us as people, and have repercussions within broader life. He explains, 'I'd like to suggest that using slides on an everyday basis could change us ... The state of mind that you enter when sliding, of simultaneous delight, madness and "voluptuous panic", can't simply disappear without trace afterwards. In this sense the "test site" isn't just in the Turbine Hall, but is also, to an extent, in the slider or person watching who's stimulated by the slides: a site within.'[4]

Who would have thought throwing caution to the wind and indulging in a moment of pure excitement could also create space for self-reflection? Perhaps returning to a childhood playfulness and whooshing down a slide is not a frivolous pursuit, but just the thing we all need in order to learn to let go.

Alex Da Corte, stills from *Rubber Pencil Devil*, 2018

Adult Bart Simpson practising tricks on his skateboard. Disney's Pinocchio slowly blowing up a large pink balloon, and bursting it with his elongating nose. A man dressed as a dice gently spinning and dancing around until he settles on two. A bored housewife playing with a set of kitchen knives while on the phone. 'What is this I am watching?', you may well ask. Here we have *Rubber Pencil Devil* which, as the opening titles explain, is 'A Play in Fifty-Seven Acts Parts / Pieces / Varieties.'

American artist Alex Da Corte offers us a looping, 175-minute stream of dreamlike video vignettes. Watching *Rubber Pencil Devil* is an experience that recalls the excitement and magnetic pull that the television holds in early childhood. Following the structure of children's television shows or extended commercial breaks, we jump between a series of characters and tales that have no connection to one another. What remains constant, however, is Da Corte's aesthetic. Simple, brightly coloured sets feature a range of familiar characters drawn from children's television or campy Americana. The artist stars as almost every character on screen, and he and his team made all of the sets and costumes from scratch.

These elements have a hand-made, amateurish quality that contributes to the nostalgia: reminders of school plays and childhood fancy dress parties. Likewise, Da Corte's exaggerated but kindly facial expressions are comforting and enthralling. Yet the events that unfold onscreen are unsettling and entirely unpredictable. The montages are uncanny in their artifice. Is this over-saturated fever dream offering us a playful distraction or revealing the darkness that lurks beneath our fantasies?

Roman Ondak, *Good Feelings in Good Times*, 2003

You may have participated in Roman Ondak's work
without even realising it. The first live performance
ever to be acquired by Tate, *Good Feelings in Good
Times* is a queue that leads nowhere. Performed at
Tate Modern on various occasions over the years,
a row of six or more actors and volunteers will
casually begin to line up. The performers blend
in with regular gallery-goers, and 'non-acting'
is encouraged by the artist. If a member of the
public asks what they are queuing for, they are not
allowed to divulge anything about the performance,
and instead must reply with vagaries such as 'we're
just queuing'.

Inevitably, unknowing bystanders join their
ranks. In some ways, the work is an absurdist prank,
playing on the quintessentially British patience and
willingness to form an orderly line, and exploiting
visitors' fears of missing out. Likewise, it presents
a strange mirroring of the operations that support
a busy institution like Tate Modern, which allows the
work to be camouflaged among the other queues
that abound, for the cloakroom, ticketing, and the
toilets. But it is also a homage to the act of queuing
and the temporary community it creates.

Growing up in Bratislava, Slovakia, before the
fall of communism in 1989, Ondak describes his
memories of the lines 'that in the 1970s and 1980s
often used to form in front of shops ... In what
everybody then called the bad times, people were
capable of patiently waiting in queues and feeling
good about it, because they thought at the end of
it they'd probably get what they were hoping for.'[5]
While it is a work that you may see and not even
notice, the magic to be found in something as
mundane as the act of queuing itself – rather than
the reward – is just as much part of Ondak's work as
the performance.

Does it have to be so serious?

Mildred Thompson, *String Theory VI*, 1999

American artist Mildred Thompson's vibrant paintings possess an irresistible effervescence. Their bold colours and energetic lines brim with delight and verve. Across a career spanning more than four decades, Thompson's visual language was informed by her wide-ranging interests, from art history to physics, astronomy, mathematics and music. In particular, she sought to use her painting to represent scientific theories visually. To use her words, her work 'reflects a personal interpretation of the universe.'[6]

In the late 1990s, Thompson turned her attention to string theory, an area of quantum physics. Put simply, the theory proposes that, at a sub-atomic level, all matter is made up of tiny one-dimensional string-like objects that vibrate at different frequencies. *String Theory VI* is a brilliant rendering of how this might look, if it were possible to see these minuscule forms. In Thompson's imagining, the strings are formed of vivid yellows, pinks, greens and blues, arranged in a whirring composition spiralling outwards from calligraphic lines at their centre, perhaps denoting the frequencies acting upon them. Like violin strings being plucked in an orchestra, the effect is a symphony of colour.

Born in 1936 in Jacksonville, Florida, Thompson chose to leave the US for Europe in the late 1960s because of the racism and sexism she experienced as an African-American woman. Returning in 1985 to live in Atlanta, Georgia, the *String Theory* series were the last paintings she made before her death in 2003. It is thrilling to see the very essence of life as we know it understood as so fundamentally beautiful. Through this lens, everything in the universe is comprised of the same stuff. *String Theory VI* attests to how, in the right hands, there can be a profound spirituality within particle physics, and at the core of existence, there can be joy.

Mona Hatoum, *Van Gogh's Back*, 1995

Van Gogh's Back is not a photograph of the back of the artist Vincent Van Gogh, but of the back of a hirsute man, his hair soaped and swirled into patterns reminiscent of Van Gogh's signature thick brushstrokes in his famed painting *Starry Night* (1889). At the mention of Van Gogh, the resemblance is immediately recognisable. The softly undulating whirls and eddies in *Starry Night* suggest an absorption and delight in painting. Here, too, one imagines the artist Mona Hatoum making a playful discovery while washing the back of her companion. But it is also a deeply intimate piece, suggesting a shared moment of tenderness: one imagines the careful massaging gestures against the man's soft skin that must have preceded this image.

Yet in Western cultures, there is often an uneasy relationship to body hair. By representing it here in such a loving and matter-of-fact way, Hatoum does much to subvert such preconceptions. Hair features heavily within her artistic practice. In one work, she collected strands of her own hair, rolled them into round beads and displayed them as a necklace. In another, she wove strands of light and dark hair to form a patchwork quilt checkerboard pattern and suspended it from the wall. Hair takes on many qualities within Hatoum's work, but in part it acts as evidence of being alive, of inhabiting a body that grows and sheds hair. It could also be a reference to her Palestinian origins: loose hairs are displaced, uprooted, and recall the absence of the body from which they came. Within the context of much of the artist's work, *Van Gogh's Back* is uncharacteristically playful, revelling in the joys of bath time and unlikely artistic resonances.

Does it matter
who makes it?

Does it matter
who makes it?

Does it matter
who makes it?

Does it matter
who makes it?

Does it matter
who makes it?

Does it matter
who makes it?

Does it matter
who makes it?

'If our greatest artwork is the way that we live our lives, then a relationship is the ultimate collaboration,' begins Zackary Drucker and Rhys Ernst's photo-book *Relationship*.[1] The photographs that follow document the six years Drucker and Ernst spent together as a couple, six years during which both their lives underwent major and parallel changes. Over that time, they were each experiencing gender-affirming transitions: Drucker to correspond to her female identity and Ernst to correspond to his male.

The pair, who both live and work in the United States, began dating in 2008, shortly after they had each started taking hormones. The images in the book are loosely chronological. In the first, they snap a selfie in the mirror as they embrace, the photograph blurred in the movement of Ernst leaning in to kiss Drucker on the cheek. In another, they hold each other tenderly on the front porch of their home. These are private images that they took for their own pleasure, as their own kind of visual diary. Although they are both artists, they never had it in mind to exhibit these works. As Drucker explains, 'We were just photographing the person that we were in love with and obsessed with. We were really just enamoured with each other. There was no piece of that that was like "this is the photograph of my trans lover." It was "this is my lover."'[2]

This sense of normalcy is crucial. In the wrong hands, a depiction of trans–trans love could have been sensationalised. Although today the transgender community is more visible than ever, trans stories are most often told by non-trans people. Instances of trans people having authorship over how they are represented are still rare, and were even more so when these works were made. It was for this reason that, despite no longer being together, Drucker and Ernst chose to publish these images.

The prevalent societal pressures to conform to narrowly-defined gender stereotypes mean that any depiction of a gender-nonconforming body is a vital act of rebellion. They provide a beacon for those within queer and trans communities, and particularly to a younger generation, showing that they need not be relegated to invisibility. Among a wider public, these photographs may serve to inform and educate those outside of these communities about bodies and lifestyles of which they had no prior knowledge.

The fact that Drucker and Ernst had full authorial control is important. We are shown their relationship with each other, with themselves and with their bodies, on their own terms. They describe experiences of which they have first-hand knowledge. This question of the primacy of lived experience when addressing certain subjects within art has generated much debate in recent years. Perhaps the most notable example has been the furore surrounding the exhibition of white American

Zackary Drucker & Rhys Ernst, *Relationship #23 (The Longest Day of the Year)*
from the series *Relationship*, 2011

Parker Bright protesting *Open Casket* by Dana Schutz, at Whitney Biennial, 2017

Does it matter who makes it?

artist Dana Schutz's painting *Open Casket* in the 2017 Whitney Biennial, a major recurring exhibition of contemporary art in New York.

In her characteristic painterly style, Schutz had opted to depict the widely circulated image of the mutilated corpse of Emmett Till, a fourteen-year-old Black boy who was tortured, castrated and killed by two white men in 1955 for reportedly flirting with a white shop assistant. His murderers were acquitted, but later confessed in a paid interview. For the funeral, Till's mother chose an open casket so people could see the violence he had suffered, and the newspaper image of his dead body raised awareness among white Americans who had previously paid little attention to the struggle for civil rights. To many African Americans, however, the image served as a terrifying warning of the violence that could befall them for even the most minor transgression.

Within hours of the Whitney opening, Schutz's painting had divided opinion. A social media post from the opening event where a leading art critic described the painting as 'beautiful' immediately drew outrage. The following day, artist Parker Bright arrived at the exhibition in protest. He stood in front of the work, his body blocking any clear view of it, wearing a t-shirt with the words 'Black Death Spectacle' and engaging visitors in conversation about the ramifications of its inclusion in the Biennial. Within days, an open letter by British artist Hannah Black galvanised protest internationally. The letter argued that the painting by a white artist co-opted Black suffering for 'profit and fun'.[3] In no uncertain terms, it implored that 'non-Black artists who sincerely wish to highlight the shameful nature of white violence should, first of all, stop treating Black pain as raw material. The subject matter is not Schutz's; white free speech and white creative freedom have been founded on the constraint of others, and are not natural rights. The painting must go.'[4]

One of the principal arguments in the open letter's call for the painting's removal was that for Schutz to paint a photograph of Emmett Till was an act of cultural appropriation. By assuming that she had the right to respond to the photograph through her art, it was held that she had stepped beyond any experience a woman in her position could understand, in a way that was insensitive, reductive and self-serving.

Addressing these claims, Schutz responded, 'I don't know what it is like to be Black in America, but I do know what it is like to be a mother.'[5] Her supporters saw her choice of subject as an exercise of her artistic freedom and, in her empathy with Till's mother, viewed the work as a powerful and compelling expression of allyship. In seeking to justify her intentions, Schutz explained further, 'I do think that it is better to try to engage something extremely uncomfortable, maybe impossible, and fail, than to not respond at all.'[6]

Schutz also confirmed that the painting would not be sold. However, as *Open Casket* played a part in representing the artist in a major exhibition that increased her public profile, it is impossible to divorce it from all financial reward. As such, it appeared to be capitalising on Black pain, at a time when images of violence against Black bodies continue to circulate in the media daily, and brutalities against Black people still go unpunished.

Ultimately, in approaching this subject from her position as a successful white artist, with all the privilege that goes along with that, the question of what Schutz was contributing to the urgent context of systemic racism and ongoing racial injustice hung in the air. Is provoking uncomfortable conversations always a sign of artistic achievement? Is it possible to paint a dead child with sensitivity? Does artistic freedom have its limits?

Christine and Margaret Wertheim and the Institute For Figuring, *Bleached Reef* from *Crochet Coral Reef*, 2005–ongoing

Encountering Christine and Margaret Wertheim's *Bleached Reef* is like being transported into a fantastical world underwater. Undulating frills, densely packed bobbles, spiralling towers and creeping tendrils are conjured from all sorts of materials ranging from wool, cotton and silk, to plastic shopping bags, old videotape and military-grade electroluminescent wire.

In 2005, after reading about the devastation of the Great Barrier Reef in their native Queensland, Australia, identical twins the Wertheims had the idea to crochet their own reef as an artistic response. They posted a call-out online inviting collaborators to submit contributions. Very quickly, a whole variety of forms began to appear in the post to combine with the models they were making. There is a great deal of mathematics involved in crochet, and these coralline forms are the simplest way to model hyperbolic surfaces or, in other words, prove some very complex mathematical theorem.

Bleached Reef is made almost entirely by the Wertheims, with special additions from a dozen long-time contributors. It shows the effects of global warming as rising sea temperatures stress corals, causing them to lose colour. Those that are severely bleached often die. The *Crochet Coral Reef* project is symbolic of what can be achieved when communities work collaboratively. Over the years, nearly 20,000 participants around the world have contributed to more than forty 'Satellite Reefs'. Each reef contains many thousands of hours of labour, mostly by women, and offers a message of hope in the face of global issues with which we may feel powerless to grapple alone. The project seeks to emulate the example that corals themselves have set for us: a head of coral is created by thousands of tiny coral polyps working together. As Margaret Wertheim sees it: 'We humans, each of us, are like a coral polyp. Individually we're insignificant and probably powerless, but together I believe we can do things. We are all corals now. We are all at risk.'[7]

Does it matter who makes it?

Bharti Kher, *Virus XI*, 2020

If you were to purchase a work from Bharti Kher's *Virus* series, you would receive a beautifully crafted mahogany and brass box filled with ten thousand large hand-dyed bindis, and a set of instructions on how to assemble the work yourself. It is important to Kher that part of owning the piece is also owning the experience of the careful and absorbing process that goes into making it. Central to the work is this investment of time, of which the work itself is a testament.

Each edition also comes with a set of predictions for the future. This is a thirty-year project, beginning in 2010 and ending in 2039, with the artist creating a new bindi spiral work each year in a different colour, accompanied by an updated text. These range from diaristic observations from the artist's life, to news items and informed forecasts of the developments Kher envisages that year will bring. For example, in the text accompanying *Virus XI* in 2020, among her many predictions she anticipates that in 2025, 'Phone calls are three-dimensional holographic images of both people'; in 2035, 'The European Union finally collapses with several splits and formations of new fragile alliances'; and in 2039, simply 'I am 70 now. See you then.'

The text paints a dystopian picture, where it can be hard to distinguish prediction from fact. Born in London but living in New Delhi since 1992, Kher often incorporates bindis into her work. Worn daily by women of many cultures in South Asia, these small discs, positioned on the forehead, represent 'the third eye', considered in the Dharmic spiritual traditions of India as a point of immense power and a gateway to a higher consciousness. In this sense, the cumulative spiral on the wall may represent an opening in time, a symbol of the actual and imagined journeys through time that this work contains within it.

Louise Bourgeois, *Maman*, 1999
Installation view, Tate Modern, 2007

Are you afraid of spiders? What about gigantic metal ones that tower over you on sharp pointy legs? Louise Bourgeois' sculpture *Maman* looks like it walked straight out of a science-fiction film. Its dense body balances atop eight irregular rough-hewn legs as though preparing to scurry into attack at any moment. Growing from its underbelly is a sac made from steel mesh, and containing a spawn of grey and white marble eggs. Thus, along with the title *Maman* (French for 'mummy'), the spider's menacing aspect is reframed as that of a mother protecting its young. On the one hand, engaging with the work from below looking up, we find ourselves cast as another of its children; on the other, the spider's predatory stance suggests we might be its next prey.

This is the largest among a series of spider sculptures Bourgeois made in the mid to late 1990s, when she was already in her eighties. 'The spiders were an ode to my mother,' Bourgeois has said. 'She was a tapestry woman, and like a spider, was a weaver. She protected me and was my best friend.'[8] Autobiographical imagery relating to her past pervades Bourgeois' work. In many ways, her childhood trauma fuelled her artistic practice, which offered her a kind of therapy. But, as has been the case for many women artists, her biography tends to be talked about far more than the art itself. Her art is often interpreted as an illustration of her life story, rather than understood on its own terms. Nonetheless, it is the way she mines her own personal histories so unflinchingly that allows us to connect with our own. Bourgeois is able to tap into her deepest fears and yearnings and, by putting them out into the world for us to contemplate, shows that they can be contained and overcome.

Janine Antoni, *Mom and Dad*, 1994

American artist Janine Antoni's series of three photographs titled *Mom and Dad* are just that: three depictions of her mother and father. But even a cursory glance reveals that these are not your everyday family portraits. Antoni has dressed and made up her parents to appear as one another, her mother to look like her father, and vice versa. Decked out as each other, they both look like they've had some serious work done – it surely is no coincidence that the artist's father is a plastic surgeon.

Antoni learned how to use prosthetics to make these photographs. She could have paid a professional prosthetic make-up artist who would have achieved a much more convincing likeness, but it was important for her that she executed the transformations herself. Describing the process, she explains, 'What I was arriving at was a half-mom, half-dad creature, but to create this composite I had to reverse our roles in the sense that my parents made me, and now I was remaking them.' In doing so, she realised that she was making a 'self-portrait, because that is what I am, a biological composite of the two.'[9]

Our parents are often our earliest role models in terms of how we understand gender. These deeply personal photographs highlight the ways that gender is constructed within society. Even the way they sit conforms to gender stereotypes, with the father/'father' sitting proudly hands folded in his lap, while the mother/'mother' has a coquettish sideways gaze, her fingers casually intertwined. In representing each other, they reveal how gender is performed within even the most mundane of portrait poses. They also show that in whatever gender role they present themselves, they remain the artist's parents, lovingly referred to as 'Mom and Dad'.

Does it matter who makes it?

Trevor Paglen, *Prototype for a Nonfunctional Satellite (Design 4; Build 4),* **2013**

Imagine looking up at a star in the night sky and knowing that it had been put there purely for you to enjoy. In a series of projects from 2012 to 2018, American artist Trevor Paglen sought to make that a reality. Working with a team of aerospace engineers, he built several prototypes for a satellite that would exist solely as an artistic gesture. It would be the first satellite in space that was not there in connection to corporate or military interests. Its mirrored surfaces would reflect sunlight down to earth when launched into low-earth orbit, making the satellite visible to the naked eye as a twinkling, slow-moving star: a public sculpture in space.

For this work, Paglen was inspired by early spacecraft that NASA built in the late 1950s and early 1960s. This was a time when the goal was primarily to put something into orbit. The satellite's functionality had not yet been defined, and as a result the designs were imaginative. Paglen's works ask what technology could look like if it were freed from the constraints of commercial or military ambitions.

Following a succession of prototypes and three years of engineering development, Paglen's satellite now titled *Orbital Reflector* was successfully launched into space on 3 December 2018, and its reflective surfaces were due to inflate upon receiving clearance from the Federal Communications Commission. Unfortunately, this coincided with the United States federal government shutdown that ran for thirty-five days from December to January. By the time the government was re-opened, it was no longer possible to track. Ultimately, Paglen aimed to question who owns space, and who decides how it is used. With the trajectory of *Orbital Reflector*, perhaps we have our answer. And yet, can a nonfunctional project truly fail if it had no purpose to begin with? If anything, it encourages us to look up at the night sky and envision a new reality.

Anthea Hamilton, *Project for a Door (After Gaetano Pesce)*, installation at SculptureCenter, New York, 2015

Anthea Hamilton's *Project for a Door (After Gaetano Pesce)* did not start out as her own idea. It is one among a series of works she calls her 'Grand Remakes', physical realisations of unusual images drawn from her extensive visual archive. The starting point for this work was a black-and-white photograph of an architectural model for the entrance to a Manhattan apartment building, made by Italian designer Gaetano Pesce in 1972. His plan for the doorway was for people to enter by passing through the spread legs and underneath the splayed buttocks of a gigantic male form. 'Imagine walking along the street and suddenly you see a building with that door,' Pesce asks. 'Your imagination explodes. You can't help but be surprised – and that opens a door in our conservative minds. Surprise is very healthy in the city.'[10]

Surprise can be very healthy in art galleries too. Perhaps it was with this in mind that Hamilton chose to re-create the work on an architectural scale in 2015. The original model had been relatively small and Pesce's vision was unfortunately never realised. In Hamilton's, hands, it was constructed at 10m (33ft) and painted gold. When she was nominated for the prestigious Turner Prize in 2016, the work was installed at Tate Britain. The *Guardian* newspaper described it as 'the UK's favourite spot for a selfie'. Pesce was delighted that his idea, which had lain dormant for so long, was able to spark something in Hamilton, and that she could make it her own. More than an act of appropriation, this might be better understood as an homage. In the hands of a contemporary British artist, an idea formed more than forty years previously was brought to life, and in the process, could take on new meanings and delight new audiences.

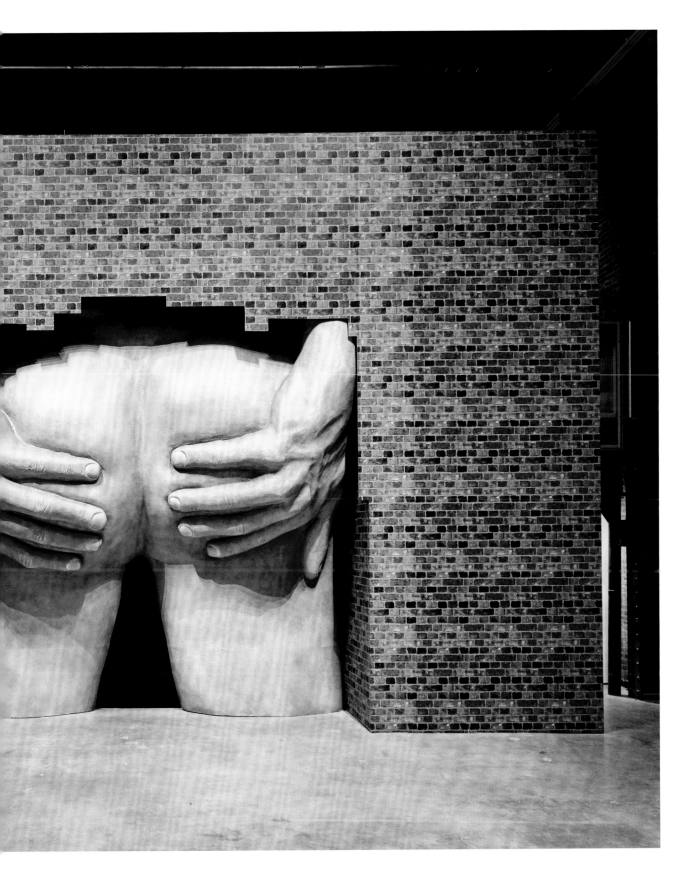

Where do you
draw the line?
Where do you
draw the line?
Where do you
draw the line?
Where do you
draw the line?
Where do you
draw the line?
Where do you
draw the line?
Where do you
draw the line?

In 1998, British artist Tracey Emin chose to display her bed as a work of art. It wasn't just her bed, it was her bed with everything around it, exactly as she had left it after a particularly difficult stretch in her life. In times of emotional struggle, one's bed can be a place to hide away from the world, a place of shelter and solace. Emin's bed is unmade with rumpled sheets and pillows, nylon tights and a bath towel strewn across it. The bedside table and adjoining rug are scattered with a mess of dirty tissues, empty vodka bottles, pill packets, cigarettes, a used ashtray, Polaroids, condoms, a pregnancy test, and period-stained underwear, among other personal effects. Nominated for the 1999 Turner Prize and subsequently exhibited at Tate Britain, the work and the artist herself became an immediate media sensation. So much so that even now, more than twenty years later, it retains its notoriety.

At the time, it drew strong reactions inside and outside the art world. Many critics responded with vitriol, seeing the work as an affront and touting that anyone could display their messy bed. During the course of the exhibition, two performance artists began a pillow fight on the bed and had to be removed by police. In a separate incident, a woman rushed the bed with cleaning spray in an effort to clear away what she saw as filth and a 'bad example to young women'.[1] However, all in all, it was a fantastically popular exhibit, with visitors flocking to see it in their droves. It remains to this day one of the most popular Tate exhibitions on record. But why? What is this love affair we have with art that shocks?

My Bed was made in the summer of 1998 in a council flat in Waterloo. Emin had lain in bed for days following a traumatic relationship breakdown, experiencing depression and suicidal thoughts, and drinking away her sorrows. She describes how she finally got up and saw her bed with fresh eyes,

'And at that moment I saw it, and it looked fucking brilliant. And I thought, this wouldn't be the worst place for me to die; this is a beautiful place that's kept me alive. And then I took everything out of my bedroom and made it into an installation.'[2] As with Marcel Duchamp's *Fountain*, it was the shift in context that made something commonplace into art. But, importantly, Emin was able to use this latent potential in everyday objects for her own personal breakthrough. She explains, 'I saw it out of that environment and, subconsciously, I saw myself out of that environment, and I saw a way for my future that wasn't a failure, that wasn't desperate. One that wasn't suicidal, that wasn't losing, that wasn't alcoholic, anorexic, unloved.'[3]

In doing so, she exposed the most intimate trappings of her personal life and all its imperfections, without shame. It was a startling expression of vulnerability, resilience and redemption: a monument to the struggles of a woman in her mid-thirties and a testament to overcoming them. Perhaps it was this willingness to bare all so unapologetically that shocked people at the time. And maybe it is that same sentiment that allows it to still resonate today, as a trailblazing feminist act.

Five years later, in an untitled work, American artist Andrea Fraser likewise shocked audiences with work that asserted control of her position as an artist in new and unprecedented ways. She approached her gallery to organise a commission with a private collector. The arrangement she proposed was a sexual encounter with the collector to be filmed on videotape and issued in an edition of five, the first copy of which would go to the participant. Accordingly, an unidentified collector was enlisted and agreed to purchase the video in advance for an undisclosed sum to participate in this work of art. The resulting video is sixty minutes of silent, unedited footage shot from a fixed point in a

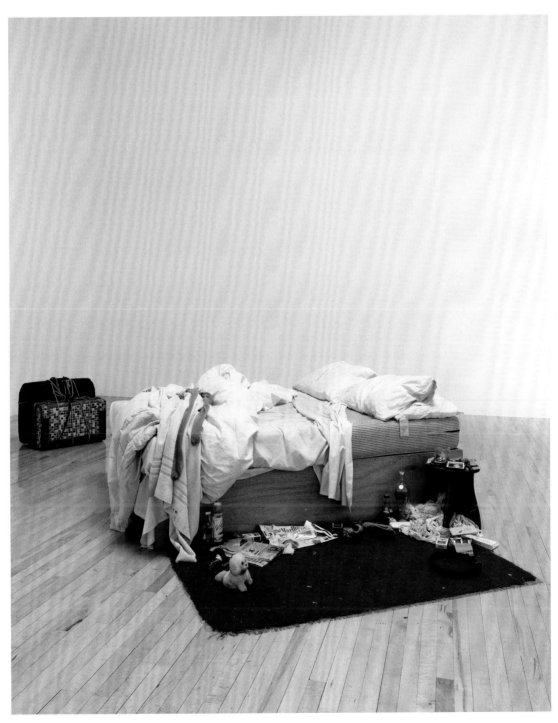

Tracey Emin, *My Bed*, 1998

Andrea Fraser, video stills from *Untitled*, 2003

New York hotel room. It begins with Fraser entering the room with two glasses, followed by the collector.

While many critics immediately drew comparisons with prostitution, decried exploitation or personal debasement, Fraser describes it differently: 'My own experience of doing the piece was really very empowering and quite in line with my understanding of my own feminism. It was my idea, it was my scenario, I was producing a piece that I would own, I was very much in control of the process. I never felt used by the collector. In fact, I was much more concerned about using him. And showing it has also been empowering – terrifying, but empowering.'[4] Everyone involved chose to be a part of the work, and committed to it willingly. Importantly, Fraser also insisted upon contractual restrictions on the five editions of the work, including the collector's first edition upon its sale to the Whitney Museum, that limit how the work can be sold, displayed or presented.

Ultimately, the work questions whether selling one's art is a form of prostitution. To be an artist often involves tapping into deeply personal and intimate experiences, and then putting the result out into the world for sale. The art world is structured around a very particular system of exchange, an infrastructure that profits from the emotional labour of artists who distil distressing existential questions so that we can contemplate them from a position of safety.

The work asks what collectors want from artists and, for that matter, what is it that we want as audiences? Certainly, as the following pages attest, outrage makes for good headlines and large audiences. It is said, that which has the capacity to shock reflects the concerns and taboos of the period. Our times may be catching up with the openness around mental health that Emin showed in displaying her bed, but Fraser's work still feels raw given the persistent stigma surrounding sex work and women asserting control of their bodies and sexuality. If contemporary art is formed by and of contemporary culture, then a key role for artists is pushing at that culture's limits and exposing the rules and contradictions by which it operates.

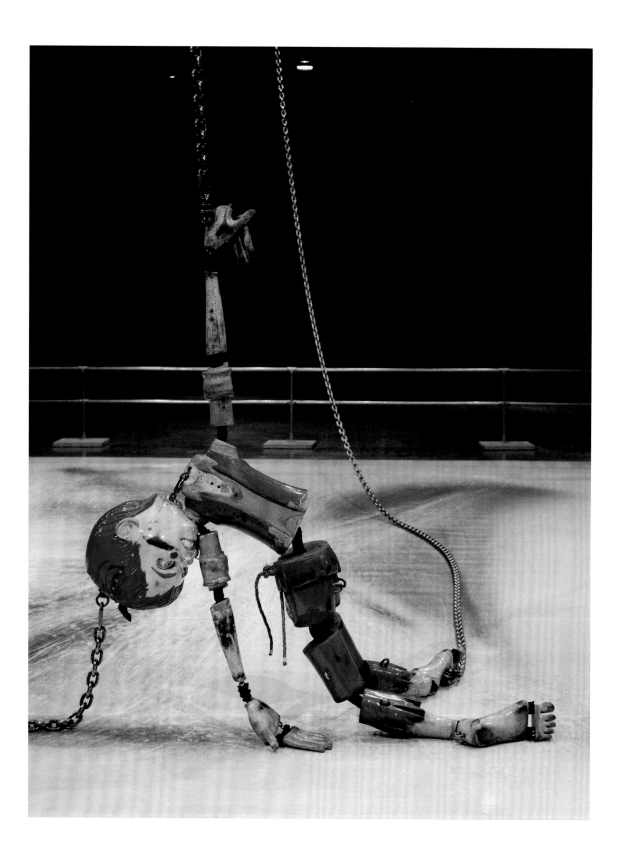

Where do you draw the line?

Jordan Wolfson, *Colored sculpture*, 2016

Suppose the science-fiction trope someday comes true that artificial intelligence will evolve to rise up and turn on humankind for abuses suffered. In that event, I am willing to wager that Jordan Wolfson's animatronic *Colored sculpture* will be leading the charge. This automated sculptural work comprises a 2-m (6½-ft) tall puppet, fixed to a square gantry by chains at its head, wrist and ankle. With its gap-toothed grin, red hair and freckles, the puppet is inspired by American depictions of boyhood in cartoons and comic strips from the 1940s and 1950s. But belying his cute, wholesome exterior, there is something terrifying about him.

His eyes are equipped with facial recognition technology that enables them to make eye contact with visitors and eerily follow them around the room. Even the way the joints are positioned on the puppet is unsettling, since they seem to be placed slightly off where they belong. Located as they are above the knee and below the elbow, each movement appears as a break rather than a bend. They are also multi-directional and form all kinds of back-breaking, ankle-twisting contortions.

The puppet is subjected to a fifteen-minute onslaught of battery as the chains slowly winch him up then slam him headfirst into the ground. It's hard to watch. You wince at the relentless brutality, yet the puppet's unshakeable grin and piercing eyes denote an unhinged menace that makes you glad to see it chained. A deadpan monologue spews out like a sadistic nursery rhyme: 'Two to kill you, three to hold you, four to bleed you, five to touch you', up to eighteen, before abruptly breaking into Percy Sledge's 1966 soul hit *When a Man Loves a Woman*. It is wholly inappropriate to the setting and further contributes to the sense of watching an abomination. What could all this possibly mean? Wolfson does not ascribe meaning. He explains, 'Every decision I made in making this artwork, I didn't ask myself intellectually, I asked myself intuitively and physically, what did I feel more for?'[5] The work is designed to be triggering, and yet the artifice is plain. The puppet is clearly not a real boy, but the violence it undergoes certainly feels very real. The artist has said that this work, with its double-edged title, also plays on the overt and coded racism that exists even within the histories of beloved characters like Huckleberry Finn and Howdy Doody.

Xu Bing, *A Case Study of Transference*, 1994

In a Beijing gallery in 1994, Chinese artist Xu Bing created a special enclosure to house two pigs he had trained to mate with one another. The ground was covered in open books as the setting for their encounter. The boar was stamped all over in nonsensically arranged Roman alphabet letters, and the sow was covered in invented Chinese characters. Like many Chinese intellectuals of the time, Xu had spent a significant period working on a farm under the Cultural Revolution, and so had developed skills in animal husbandry.

Before the event, he had been concerned the pigs would not perform in the busy and unfamiliar confines of the gallery space, but when it came to it, the pigs copulated loudly and for some time. Xu describes, 'These two creatures, devoid of human consciousness, yet carrying on their bodies the marks of human civilization, engage in the most primal form of "social intercourse". The absolute directness of this undertaking produces a result that is both unthinkable and worth thinking about. In watching the behavior of the two pigs, we are led to reflect on human behavior.'[6]

In this collision of nature and culture, the pigs seemed very comfortable in their roles, while the humans in the room watched on in amused embarrassment. In covering the boar in Roman letters, and the sow in pseudo-Chinese characters, Xu was also staging a darkly comic analogy for the relationship between East and West. The work suggested a critique of his contemporaries' passive embrace of Western culture and portrayed the consumption of other cultures as an aggressive and primal act.

The animalistic display and raw urges running loose within the high culture space of the gallery was shocking. In recent years, showings of video recordings of the work have drawn angry critique from animal rights groups. As contexts shift and times change, so too do potential transgressions and what has the capacity to shock.

Maurizio Cattelan, *America*, 2016

When *Fountain* was exhibited in 1917, its creator separated a porcelain urinal from its original function and presented it as art. Almost a century later, Italian artist Maurizio Cattelan displayed another toilet as art – but this one was fully available for use. Installed in a toilet cubicle at the Guggenheim Museum in New York, *America* is a precise replica of their standard facilities – but cast in 18-carat solid gold. It is estimated that over the course of its exhibition, over 100,000 people braved the long lines to use it.

Made from 103kg (227lb) of gold, and valued at over four million US dollars as bullion in September 2019, for most of us it is likely the most expensive object we've ever been permitted to touch, much less been invited to do our business on. While a golden throne may represent the ultimate luxury and symbol of excess, the toilet is perhaps the greatest leveller. Ultimately, these physical needs unite us all. In the words of the artist, 'Whatever you eat, a two-hundred-dollar lunch or a two-dollar hot dog, the results are the same, toilet-wise.'[7]

Titled *America* and first shown in the wake of Donald Trump's election in 2016, Cattelan's work is also a commentary on the aspirations for wealth and success within the American Dream, and likely also the state of US politics – although it should be noted that the work was conceived before Trump's presidential campaign. Beyond the presidential election, the life cycle of this object did not cease to generate headlines. When the White House approached the Guggenheim about borrowing a Van Gogh painting to adorn its walls, the museum responded by recommending *America* instead. In 2019, it was exhibited at Blenheim Palace in the UK, installed in what had once been Winston Churchill's bathroom. Within days, it was stolen. Many wondered if its disappearance was a prank enacted by the artist himself, yet the artwork was never recovered despite several arrests. Nonetheless, Cattelan certainly enjoyed the speculation, appearing in an advertisement for an Italian insurance company, clutching a cardboard cut-out of the toilet, behind the slogan: 'Great artists steal.'

Where do you draw the line?

Eddie Peake, *Touch*, 2012, performed at Royal Academy, London, 1 March 2012

While we may be accustomed to seeing painted nudes on gallery walls, being confronted with actual nudity in an art gallery still has the potential to shock – especially if it's naked men. In 2012, British artist Eddie Peake staged a naked five-a-side football match at the Royal Academy in London. Over the course of the 30-minute game, the initial strangeness of this constructed situation dissipated, and the audience grew accustomed to the players' nudity as they became more invested in the outcome of the match.

It is integral to the work that the players play as if they are clothed. Peake explains, 'I say to the footballers: "Don't play like you're performing in art. Play like you're in a football match to win."'[8] This is important because the players' commitment to this spectator sport allows viewers to feel confident in their right to watch. But it never stops feeling voyeuristic. It is always both a football match, and ten naked men on display. We know we are supposed to be looking – clearly, a spectacle is being presented – but where are we supposed to look, and is it OK if it makes us feel things? Can we resist objectifying these men? Does it matter if we do?

Here, Peake puts the male body on display as both a sculptural object and a sexual object. As the work's title, *Touch*, suggests, there is a palpable erotic charge within the exhibition of bodies in play, and the possibility for contact. *Touch* poses a challenge to the ways we are taught to think about masculinity. As the artist puts it, 'I think we're very accustomed culturally to the sight and fetishisation, frankly, of the female body. So it's quite refreshing, I suppose, for a culture at large to be offered the opportunity to enjoy the male nude.'[9]

Where do you draw the line?

Komar and Melamid, *The Web's Most Wanted Painting*, **1996, from the series** *People's Choice* **(1994–7)**

Statistically speaking, this painting is likely to be your favourite work in this book. Russian artists Vitaly Komar and Alexander Melamid decided it was high time they gave the people what they wanted. Working with a high-end professional marketing firm they conducted a survey of ordinary people in fourteen different countries to determine what they like and do not like when it comes to art. Survey questions included: What's your favourite colour? In general, would you rather see paintings of outdoor scenes, or would you rather see paintings of indoor scenes? Which season would you most like to see depicted in a painting? Do you tend to favour paintings with sharp angles or ones with soft curves?

Komar and Melamid then produced a 'most wanted' painting and 'least wanted' painting for each country, according to the survey results. The world over, from Kenya to China, the USA to Ukraine, the same kind of innocuous painting topped the polls: a seaside scene with lots of blue. The voters decreed that their ideal painting was 'dishwasher-size', and as such, it is Photoshopped into a kitchen, with a Dalmatian added for scale, naturally.

Is this what becomes of art when it is designed to please everybody? So often we think of contemporary art as dividing opinion: is this what consensus looks like? I don't know about you, but to my eyes: this painting is lurid and kitsch. Am I an art snob trained in an aesthetic that appeals only to an elite audience? Or are all the voters wrong? The problem is that polling is designed to reformulate complex questions into ones with clear-cut answers. In an age when opinion polls and market research are used to determine aspects of life as wide-ranging as politics and consumer products, this series brings into question whether data has its limits. At the same time, it poses the question of whether contemporary art really serves its public.

Can anything
be art?
Can anything
be art?
Can anything
be art?
Can anything
be art?
Can anything
be art?
Can anything
be art?
Can anything
be art?
Can anything
be art?

Over the past century or so, artists have persistently pushed at the limits of what can be considered art, challenging us to expand our definitions and question our assumptions. We may accept the idea that anything can be art, but when presented with a work that leaves us perplexed, latent assumptions remain. Contemporary art continues to surprise. In this book alone we have seen art taking forms as unlikely and varied as a colourful fog, a glass of water, a website, a slide, political activism and a game of naked football, to name but a few examples. This chapter brings together a selection of works that continue to expand the field.

In 1973, British artist Hamish Fulton walked the length of the UK, from Duncansby Head near John O'Groats in Scotland to Land's End in Cornwall. He covered a distance of 1,022 miles (1,645km) in forty-seven days in what was to become a life-shaping experience. From then onwards, Fulton decided to make the act of walking his art form, whether as a means of connecting with nature, building community, raising political questions around land rights, or as a spiritual and meditative exercise. Although the experience of the walks themselves rest with Fulton and his collaborators alone, as viewers, we can engage with them through his artworks involving descriptive texts, distinctive graphics and documentary photographs.

Seven Days Walking and Seven Nights Camping in a Wood Scotland March 1985, for example, helps us to imagine the experience of a week's camping in the Cairngorms, one of the last remaining true wildernesses in the United Kingdom. A fragmented flow of text evokes a sequence of moments and arouses the senses, from 'cold wind', to the 'wet ground', or 'the repeated song of a bird.' As the observations accumulate, they build up a sense of place to the point that something like 'morning bright sun through the trees' feels incredibly vivid. Describing his approach, Fulton explains, 'What I'm interested in is presenting a sort of skeleton of something, and then the viewer fills in what's missing, maybe from your own experience.'[1] With these allusions to his own experience, he encourages us to summon our own.

Coming of age in the 1960s, Fulton's approach is emblematic of much of the most pioneering art of the time, which sought to erode the distinction between art – belonging in the pristine space of the gallery – and real life. In making walking his art form, Fulton asserted that art did not have to be about objects, but instead could be a process and a way of life. It's interesting to ponder how walking shaped his understanding of art-making, but also how it changed his approach to walking too. Positioning something as art allows you to expand your usual frame of reference, and invites you to consider it differently. The act of walking as art,

SEVEN DAYS WALKING

SOUND OF THE STREAM · NO BIRDS SINGING · DAWN · BIRDS
PINE CONES · STONES · SOUND OF THE STREAM · DEAD TREES
PINE NEEDLES · SAND · WET GROUND · MELTED SNOW · BROW
ROCKS · ROTTING TREES · MOSS COVERED BOULDERS · ANT
MIST OVER THE HILLS · POOLS OF WATER ON FLAT ROCK · CO
ON THE HILLSIDE · PTARMIGAN · DRY GREY RIVERBED ROCK ·
ROCKS · SOUND OF THE STREAM · TWIGS IN THE SNOW · GRE
DEER TRAIL THROUGH THE HEATHER BRUSHING OFF THE SNO
GRASS AND GREEN LEAVES BENEATH OLD TREES · GREY TREE
BRANCHES · GREEN LEAVES ON OLD ANTHILLS · PINE NEEDL
DISAPPEARING · BIRD SONG · MELTING SNOW · CRACKED DEA
SNOW ON HEATHER · BRANCHES · TWIGS · MOVING GREY CLO
BIRD SONG · SOUND OF THE STREAM · HUNDREDS OF ANTS AN
ROCKS · ISLANDS OF ROCK IN THE STREAM · HALF FALLEN TRE
DEER TRACKS · FEEDING DEER · DISAPPEARING DEER · DEER
LEAVES · DEAD GRASS · WIND THROUGH THE PINE TREES · NO
THE STREAM · WET GROUND · AFTERNOON SUNLIGHT ON GRE
THE WATER · SOUND OF THE STREAM · A CLEAR REPEATED BIF
AMONG THE BROWN HEATHER AND GREEN COVERED ANT HILL
SONG · DUSK · SOUND OF THE STREAM · DEER TRACKS ON FLA
STREAM · A BRANCH IN THE STREAM · A TALL PINE TREE · DRY
OF ROCKS IN THE STREAM · FLICKERING WATER REFLECTING (
WET GROUND · DEER · DEER RUBBING TREE · FRESH DEER TRA
FLYING LOW THROUGH THE TREES · NO SOUNDS OF THE BIG
IN THE DARK · GREY LIGHT · SNOWFLAKES FALLING · SNOW RC
TREE TRUNKS · WHITE LINES OF SNOW ON FALLEN TREES · A H
BENT LOW WITH THE WEIGHT OF SNOW · IN THE DISTANCE TWO
OF UPROOTED TREES IN THE SNOW · FIVE OR SIX DEER RUNNI
A TALL PINE TREE CALLING IN THE WIND AND SNOW · ROUND
LIGHT GREY SKY · SNOWING · BLUE SKY WHITE SKY GREY SK
AND STOP RUN UPHILL INTO THE TREES STOP RUN DISAPPEAR
ANTHILLS AND BUSHES · SNOW COVERED SAND · DRY GREY RI
FLYING LOW THROUGH THE TREES · SNOW SMOOTHED DEER P.
ROUNDED ANTHILLS · DARK TREE TRUNKS · GREY SKY · NO SN
AND RUN MANY DARK LEGS PASSING TREE TRUNKS · UNSEEN I
BRANCHES GREEN NEEDLES · LIGHT FALL OF HAIL · COLD · STI
NO SNOW FALLING · SOUND OF THE SMALL STREAM RUNNI
BLUE SKY · SUN MELTING SNOW IN THE TREES · SNOW FAL
AT THE VERY TOP OF A LIVING TREE A SMALL GREY BREAS

SEVEN NIGHTS CAMPING IN A WOOD SCOTLAND MARCH 1985

BIRDS SINGING · SOUND OF THE STREAM · FALLEN TREES ACROSS THE STREAM · WHITE ROCKS · GREY DRY RIVERBED ROCKS · PEBBLES · SAND · PINE NEEDLES
S · FALLEN BRANCHES ON A DEER PATH · NO BIRD SONG · WIND THROUGH THE PINE TREES · ROUNDED MOUNTAINS · WIND BLOWN CLOUDS · RAIN SHOWER · SNOW FALL
BARK · FALLEN BARK ON A DEER PATH · DEER TRACKS ON THE SAND · BIRD SONG HEARD IN THE SOUND OF THE STREAM · SPLASHED ROCKS · DRY GREY RIVERBED
LANDSLIDE · WHITE ROCKS · WET ROCKS · RUSHING STREAM AT NIGHT · NO BIRD SONG AT NIGHT · BIRD SONG AT DAWN · NO BIRD SONG · GREY CLOUD · MOVING
ASHED ROCK · SAND · PINE CONES · DEAD BRACKEN · OLD RIVERBED · NEW ANT HILL · ANCIENT ROUNDED MOUNTAINS · WHITE HARE · SCATTERED WHITE ROCKS
CK · WET GROUND · BROWN BARK · WET TREE · BROWN PINE NEEDLES · DEER PATH · MORNING LIGHT · NIGHT SNOWFALL · SNOW COVERED SAND · SNOW COVERED
LES · BROWN BRACKEN · SNOW ON FALLEN TREES ACROSS THE STREAM · REEDS · SNOW FILLED DEER PATH · DEER TRACKS IN THE SNOW ON THE PATH · FRESH
OT COVERED BY SNOW BELOW A TREE · PINE CONES · A ROBIN STANDS ON AN ANTHILL · A CROW CALLING · ROBIN SINGING · GREY SKY · A FEW SNOWFLAKES FALLING
OWN BRANCHES GREEN NEEDLES · A PIGEON FLYING BETWEEN THE DEAD TREES · GREY SKY · BLUE SKY · WHITE CLOUDS · UPROOTED TREE · SNOW ON GREY DEAD
SNOW IN THE MIDDLE OF THE DAY · A FEW FLAKES OF FALLING SNOW · SUN THROUGH CLOUDS · UPROOTED TREE · A DEER STANDING STILL LOOKING MOVING
KS · FALLING SNOW FROM BRANCHES CATCHING THE SUNLIGHT · PINE CONES · TWIGS · PINE NEEDLES · SOUND OF THE STREAM · MOSS · LICHEN · MELTING SNOW
SQUIRREL TRACKS IN THE SNOW · GREY ROCKS AND GREEN LICHEN · BROWN AND GREEN HEATHER · DEER DROPPINGS BENEATH THE TREES · LIGHT GREEN MOSS
E NEEDLES · DEER TRACKS IN THE SNOW · DEER DROPPINGS BY AN ANTHILL · OLD BRACKEN STALKS · MOLEHILL · SOUND OF THE STREAM · GREY BROWN AND PINK
G DEAD TREES · REEDS · PINE BRANCHES IN THE STREAM · BROKEN PINE BRANCHES · SNOW CAPPED ROCKS IN THE STREAM · SNOW FILLED DEER PATHS WITHOUT
LAT SNOW COVERED GROUND · DEAD GRASS · A FEW SNOWFLAKES FALLING · OLD TREES · DROPS OF WATER FALLING FROM BRANCHES INTO THE SNOW · GREEN
HE STREAM · DISTANT BIRD SONG · ANTHILLS FACING SOUTH · SOUND OF THE STREAM · SMALL HERDS OF DEER STANDING MOVING DISAPPEARING · SUNLIGHT ON
DLES AND SNOW · LIFE FORCE OF THE STREAM · MORE AND MORE WATER PASSING THE ROCKS BY THE STREAM BANK · WATER FAST SUN SLOWLY · SHADOWS IN
D AIR · SMALL BIRD · SNOW ON A HILL NOT FACING THE SUN · PALE BLUE AND PINK EVENING SKY · NO STARS · SOUND OF THE STREAM · TALL GREEN JUNIPER BUSHES
NOW ON A FALLEN TREE TRUNK · LIGHT THROUGH THE TREES FROM THE WEST · PINE CONES · TWIGS AND BRANCHES BENEATH AN OLD TREE · DEER PATH · NO BIRD
ERED GROUND · AN AREA OF SNOW BENEATH PINE TREES · GREEN NEEDLES · FLECKS OF SNOW AGAINST A PALE BLUE GREY EVENING SKY · A BRANCH OVER THE
KS IN THE STREAM · FOX TRACKS IN THE SNOW THROUGH THE DEAD BRACKEN · DARKNESS · SOUND OF THE STREAM · BRIGHT MORNING SUNLIGHT ON THE FACES
OF ROCKS · THE REPEATED SONG OF A BIRD · A SHOWER OF SUNLIT SNOW FALLING FROM A BRANCH · ROCKS IN SHADOW · REPEATED BIRD SONG · SMALL STREAM
H THE BOG · OLD TREE · SMELL OF DEER · CAPERCAILLIE FLYING LOW THROUGH THE TREES · WIND BROKEN BRANCH · DEER RUBBING BRANCH · HAIL · CAPERCAILLIE
L · LIGHT SNOW FALL · SOUND OF THE SMALL STREAM · WIND BLOWING THROUGH THE PINE TREES · COLD EVENING · STARS · WARMER NIGHT · HEAVY SNOW FALL
HER AND ROCKS · ROUNDED SNOW ON PINE BRANCHES · SNOW COVERED ANTHILLS · SUDDEN LOW FLYING CAPERCAILLIE BETWEEN THE TREES · SNOW SPRAYED
R SITTING STANDING MOVING SLOWLY RUNNING DISAPPEARING INTO THE SNOW COVERED PINE TREES · RUNNING UPHILL · DOWNHILL · FRESH TRACKS · BRANCHES
TILL · RUNNING · FRESH DEER TRACKS · DEER LYING PLACES · DEER TRACKS · SUDDEN DISTURBED CAPERCAILLIE FLAPPING WINGS THROUGH TREES · DARK GROUND
UPHILL · ROUNDED ANTHILLS · OLD DEAD PINE TREE ALONE · WIND BLOWN SNOWFLAKES SIDEWAYS · CROW FLYING IN THE WIND · CROW SITTING ON THE TOP OF
· ARCHING REEDS ON FLAT GROUND · SOUND OF THE STREAM · GREY DEAD FALLEN TREES · SNOW FILLING DEER TRACKS · ROUNDED SNOW ON THE BUSHES
E · A ROBIN SINGS FROM THE VERY TOP OF A TALL LIVING PINE TREE · GREY SKY · LIGHT SNOWFALL · TWO DEER RUN BETWEEN THE SNOW ROUNDED ANTHILLS
R TRACKS · ROUNDED SNOW AT THE VERY EDGE OF THE STREAM · FALLEN DEAD TREES ACROSS THE STREAM · SNAKING COURSE OF THE STREAM · SNOW COVERED
KS · ARCHING REEDS ON FLAT GROUND · SNOW COVERED TWISTING PINE TREE ON THE SLOPE · SNOW SMOOTHED DEER PATH · SUDDEN DISTURBED CAPERCAILLIE
D BY DEER TRACKS FILLING WITH SNOW · BRANCHES BENDING WITH THE WEIGHT OF SNOW · SOUND OF THE SMALL STREAM · SUNSHINE · PATCHES OF SUNLIT SNOW
· SOUND OF THE SMALL STREAM · PALE GREY PALE BLUE YELLOW SKY IN THE LATE AFTERNOON · SMALL HERD OF DEER ONE RUBBING A BRANCH STOP LOOK TURN
G · EVENING PALE BLUE SKY BEHIND THE TREES · STRAIGHT TREES · TWISTED TREES · BRANCHES WEIGHED DOWN WITH SNOW · GREY TREE TRUNKS LIGHT BROWN
OF THE STREAM · PALE BRIGHT SUNLIGHT · SETTING SUN BETWEEN THE TREES · A FEW SNOWFLAKES FALLING · NO SNOWFLAKES FALLING · SNOWING · GREY SKY
OCKS INTO POOLS AND ON DOWN HILL TO A BIGGER STREAM · DARKNESS · NIGHT · LIGHT SNOW SHOWERS · MORNING BRIGHT SUN THROUGH THE TREES
E BRANCHES · WARMTH FROM THE SUN · A BRIGHT BLUE CLOUDLESS SKY · FALLING SNOW FROM THE BRANCHES · HOLES IN THE SNOW ON THE GROUND
NGING A TWO NOTE SONG · FOUR SINGLE BARKS FROM AN UNSEEN DEER UP A SLOPE IN THE TREES · PALE GREY CLOUDS MOVING OVER THE HILLTOPS

Hamish Fulton, *Seven Days Walking and Seven Nights Camping in a Wood Scotland March 1985*, 1985

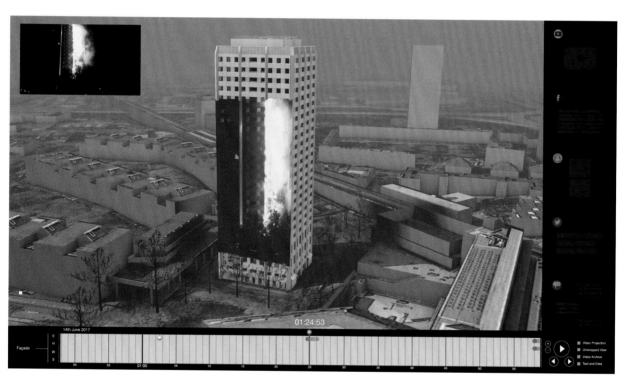

Forensic Architecture, still from *The Grenfell Tower Fire*, 2018

Can anything be art?

for Fulton, is 'a symbolic gesture of respect for nature,'[2] demonstrating the potential for walking as a way of honouring the environment, and also acknowledging Indigenous cultures that have long placed value on living in harmony with the land.

Over the years, notions of what can be considered art have continued to open up to the point that the art world has even embraced work that the artists themselves do not think of as art. In 2018, a research group called Forensic Architecture was nominated for the Turner Prize. This came as a surprise choice to many, not least the group's director, Eyal Weizman, whose bewildered initial response was that the work was 'not art', and to check with their legal counsel if the group could legitimately accept such a nomination. Made up of architects, filmmakers, journalists, lawyers, software developers and scientists, this fifteen-member collective was founded in 2010 at Goldsmiths, University of London as an architectural investigative agency.

Acting as detectives looking to expose state-sponsored injustices, Forensic Architecture uses technology and spatial analysis to uncover evidence of human rights violations. Describing their unique skill-set, Weizman explains, 'there are things that we can do with very basic tools and techniques that we have as architects, as filmmakers, as artists. The software that we all have on our laptops could be very powerful tools in confronting state and government lies.'[3] Their method of creating visual evidence to counter officially sanctioned narratives has been used in courts of law by Amnesty International and Human Rights Watch.

Recent projects have included an inquiry into the attempted genocide of the Yazidi people in Iraq by ISIL, the creation of an interactive model of a notorious prison in Syria that enabled a better understanding of human rights abuses sustained by prisoners held there, and an investigation into the 2017 Grenfell Tower fire in London that involved weaving together information gathered from social media, newscasts, and 48,000 videos submitted by hundreds of witnesses.

At this point, you may well be wondering where the art comes in. The Turner Prize stated that Forensic Architecture was nominated for 'developing highly innovative methods for sourcing and visualising evidence relating to human rights abuses around the world.'[4] Many of their members are trained in the arts, and use artists' tools to expose hidden truths. The fact that much of their work is shown in exhibitions is also likely to have played a part. The exhibition space allows them to present their research in ways different from in a court of law. In an exhibition, they can take on the freedoms art affords, and define their parameters of investigation.

Much of the time, we think of art as a space of fiction and fantasy, but it is equally a tool for conveying truths. A painting may be able to strike at the universal in a way that few other mediums can. When it came down to it, Forensic Architecture considered the nomination and decided that the honour could only aid them in their work. As with Fulton's walks, bringing their practice into the cultural realm allowed it to be considered anew by a broader audience.

Christine Sun Kim, *Game of Skill 2.0*, 2015

Game of Skill 2.0 looks like the kind of dexterity challenge that might be more at home in a fairground than a gallery. The participant is presented with a custom-built handset: a translucent blue box with multi-coloured elements inside, and an antenna-like pole coming out the top. Suspended around the room are strips of blue Velcro lined with magnetic sensors. You are told that when you brush the top of the antenna against the Velcro it emits a sound, but beyond that it is up to you to figure out how it works. If you can walk steadily forwards and keep the device moving against the line above you, you will hear a voice begin to speak. But maintaining the correct pace and keeping contact against the resistance of the Velcro is no easy task: it takes careful attention and dedication, not to mention working through a degree of frustration.

This is exactly the experience American artist Christine Sun Kim hopes to generate. She explains, 'It takes practice to perfect; it might be laborious but it's meant to make your listening feel unfamiliar and like you're learning a skill.'[5] Born deaf, Kim has spent her life learning about sound and in particular what she describes as 'sound etiquette'. These are certain behaviours she has had to adopt in order to conform to accepted social norms in a hearing world, like not slamming doors or eating too loudly.

Game of Skill 2.0 reminds hearing audiences that listening is often taken for granted. Playing by the rules of Kim's game casts the listening process anew, making it strange and laborious, necessitating its own learned behaviours. Visitors with sharper hearing may pick up snippets of audio that others may not; an indication, in the artist's words, that we each experience 'different small amounts of deafness'.[6] As for visitors who have hearing loss or who are deaf themselves, the artist has produced a short sign language video message for them – which is not subtitled for non-sign language speakers.

Haas Brothers, *Fairy Berries*, 2017

How do we distinguish between contemporary fine art, craft and design? These categories seem to be becoming ever more porous, and the lines between them more and more blurred. We are also learning that each of these terms is ideologically loaded, and likely saddled with outdated assumptions. For example, we may think of craft and design as pertaining to function, but we know that much contemporary fine art can be 'useful' too. Surely it's time to move past this. Is design 'high craft' or 'functional art'? Even the question implies hierarchies that leave a bad taste. What do these terms even mean anymore?

Of course, artists mine these grey areas and show us the need to expand our classifications through their work. American twin brothers Simon and Nikolai Haas, together known as the Haas Brothers, bring their distinctive world-making to forms ranging from ceramics, furniture, bathtubs and rugs to sculpture and more. Simon studied blacksmithing and Nikolai apprenticed as a master carver, and their work pays close attention to the unique and hand-crafted. Their series of *Fairy Berries*, for example, are miniature sculptures embellished with carefully applied layers of coloured porcelain in patterns that mimic systems of organisation found in nature. Through their practice, they have evolved a veritable universe of fantastical creatures and otherworldly botanical lifeforms. It would be a mistake to dismantle this singular creative vision into sculpture as art, furniture as design, and ceramics as craft. It's time to rethink our definitions.

Janet Cardiff, *Forty Part Motet*, 2001, installed at the Baltic Centre for Contemporary Art, 2012

Can a sound be a work of art? What about a piece of music? Canadian artist Janet Cardiff's *Forty Part Motet* takes an Elizabethan choral composition by Thomas Tallis as its starting point. Composed in the mid-sixteenth century and possibly first performed on Queen Elizabeth I's fortieth birthday, 'Spem in alium' is written for forty vocalists, arranged in eight choirs of five voices. Inspired by its unusual harmonic structure, Cardiff worked with the Salisbury Cathedral Choir and used special microphones to record each vocalist individually during their rendition.

Forty Part Motet is presented across forty free-standing speakers, one for each vocal recording, installed in a loosely oval arrangement. As a visitor, you can listen into each of the different voices right up close – a level of intimacy that might be a bit creepy if it were a live choir. As you move through and around the space, your ear picks up on different harmonies. Or you can stand in the middle and feel the full power of the vocal arrangement, designed to move in waves as the eight choirs take it in turns.

Throughout her work, Cardiff engages sound as a way to approach memory and narrative. Indeed, this experience of sound can be deeply evocative and emotive. It can be physical too: it invites you to slow down and may even give you goosebumps. It is also highly sculptural in the way that the sound fills the space and moves around. The artist says of the work, 'When I was envisioning it, I envisioned that every person walking into the room would have a different interpretation of the music because of where they walked – there's no definitive answer to the piece – and that people are making sculpture as they walk around.'[7]

When the singing ends, there is an interesting surprise as the performers' microphones were left on during a recording break. Cardiff decided not to edit out this happy accident. You hear the choristers chatting, doing vocal warm-ups, and the child sopranos playing before they begin again. You remember that these ethereal and otherworldly sounds were made by real people with everyday lives, something which makes what follows somehow all the more moving.

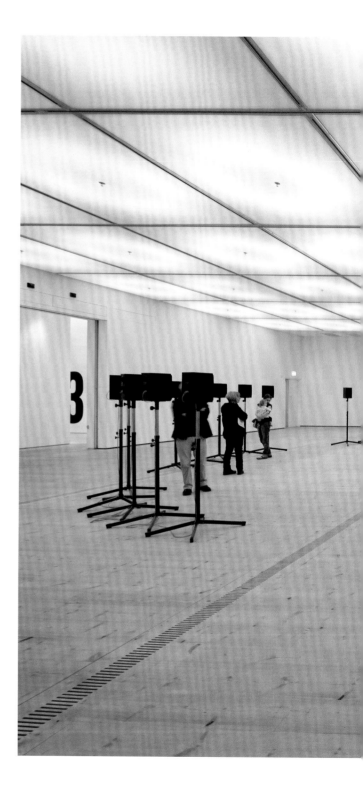

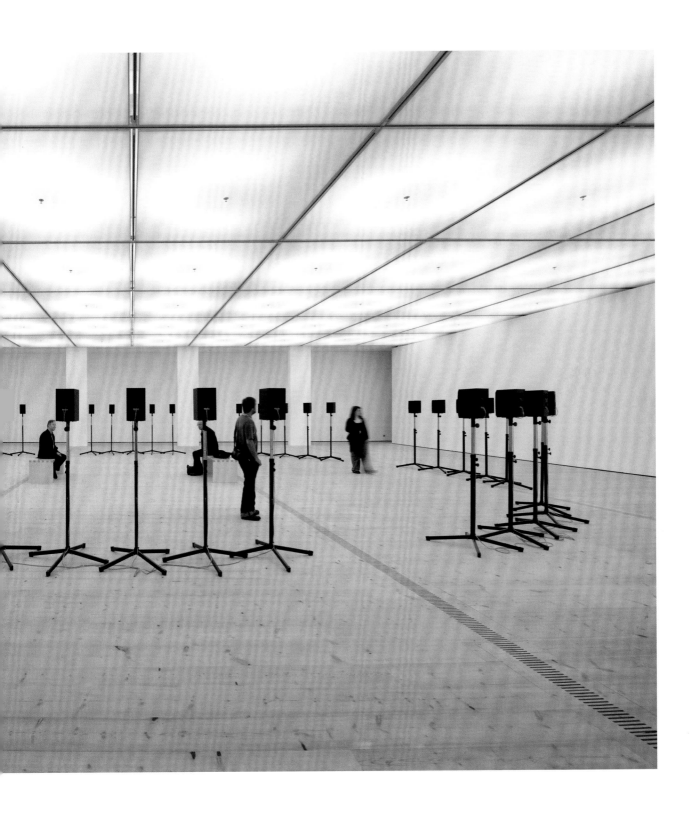

Assemble, in collaboration with Granby Four Streets CLT, *Granby Winter Garden*, **2019**

In 2015, British architectural firm Assemble won the Turner Prize for their work on the 'Granby Four Streets' project, an ongoing community-led initiative to rebuild the Liverpool neighbourhood of Granby.

What was once a thriving and diverse community had been decimated by decades of ill-thought 'regeneration' schemes. By the early 2000s, the area was sparsely populated and filled with derelict, boarded-up properties. Four streets were all that remained of the terraced houses built around 1900. Struggling to rescue them from demolition and revive the community, residents mobilised and for over twenty years campaigned to save them by taking creative action to renovate the streets themselves. In 2011, they formed the Granby Four Streets Community Land Trust (CLT), a pioneering form of community land ownership that sought to return ten empty homes to affordable housing.

Working in close collaboration with the CLT and residents, Assemble have refurbished ten houses on Cairns Street, created a ceramics workshop, and most recently the Granby Winter Garden. At the heart of the neighbourhood, this community-owned indoor garden was converted from two derelict terraced houses. Working with the fact that the floors had given way, Assemble designed striking double-height interiors allowing for trees to grow to full height within. The result includes spaces that can be used for social gatherings, gardening events and community workshops, along with an apartment for artists' residencies.

Assemble's Turner Prize win reflects a rethinking of the role of the artist as sole creator, and art as an introspective and self-contained activity, in favour of a more collaborative, community-oriented approach. In their work with the Granby Four Streets CLT, Assemble modelled a way of working that created spaces for genuine regeneration in line with local needs, both physical and social. They demonstrated a way that artists could work through a process of dialogue in service of their public.

Can anything be art?

Ian Cheng, *BOB (Bag of Beliefs)*, 2018–19

Encountering *BOB* is an experience that feels more like visiting an animal in a zoo than viewing an artwork in a gallery. Across a cage-like grid of flat screens built into the wall is a pinkish-white limbo space in which a creature called *BOB* resides, writhing around and gurgling. He resembles a red dragon or a serpent with multiple heads growing from the various branches of his wriggling body. Visitors can interact with *BOB* by downloading a custom app and selecting from a variety of 'offerings' to bestow upon him. In the process, your name will pop up in a cloud above *BOB* onscreen and, if he picks you, you can see if he likes your gift. With each offering, his algorithms evolve and *BOB* 'learns'. That is to say, as things happen to *BOB*, he starts to draw conclusions and anticipate how things will play out in future. Occasionally, he is surprised and has to adjust his expectations.

BOB stands for *Bag of Beliefs*. In making *BOB*, American artist Ian Cheng wanted to make a creature, but approach it as a painter would a canvas. *BOB* is a work of software, wherein multiple models of artificial intelligence operate at once, competing for control over *BOB*'s body and actions. Cheng refers to these conflicting motivations as 'a congress of demons' that seek to emulate those we experience ourselves.[8] He explains, 'Like us, *BOB* is never just one person.'[9]

What Cheng has created as his work of art is an unpredictable artificial lifeform that he can never truly control. It takes on its own agency, shaped by its experience and interactions. This is nothing if not ambitious, as Cheng describes, 'If I can effectively create a virtual organism, a virtual ecosystem, a thing that's alive, I can make a work that exceeds the limits of human space and human time.'[10] *BOB* ultimately exists beyond Cheng, and any of us. Best to make *BOB* a nice offering and get on his good side, because he will outlast us all.

Can anything be art?

Has it all been done before? Has it all been done before? Has it all been done before? Has it all been done before? Has it all been done before? Has it all been done before? Has it all been done before?

Contemporary art is often thought of as being about overthrowing the past and rejecting what has come before in pursuit of the new. Only the most radical art makes headlines, and so we would be forgiven for thinking that all contemporary art is conceptual. But many artists working today are breathing new life into traditional artistic mediums, and finding fresh inspiration in subjects that have been tackled a million times before.

In a recent series, Iranian-American artist Tala Madani takes on a familiar subject within the canon of European painting: that of the mother and child. Her *Shit Mom* paintings show the cherubic babies we might recognise, but the central mother figures are far from the haloed Madonna we are used to seeing. Rendered as a wobbly brown form, the titular 'Shit Mom' is not just 'shit' metaphorically but actually comprised of it in her entirety.

Throughout this series, the mother figures are beset by the demands of their children. In *Shit Mom (A Living Room #2),* she sits slumped and exhausted, stoically allowing two babies to paw at her. In a scene that is bathed in a lurid and unnatural light, we can see that a thin layer of the mother's substance is spread all over the room. This should be a disgusting sight, but in Madani's luscious handling of paint and the neon glow of the setting sun, it possesses a strange beauty, wrapped up in truth and humour.

For much of her career as a painter, Madani did not paint women. Feeling that the female body had been so objectified within the history of painting, she was reluctant to take on the subject at all. It was only after becoming a mother herself that she began to make these works. Historic idealised depictions of motherhood still carry a lot of weight. Culturally and socially, there remains a great deal of pressure to uphold impossible standards of parenting, and stigma in moments where we might fall short of perfection. In a world where motherhood is presented as being on a par with sainthood – at least if you're doing it correctly – even the phrase 'Shit Mom' feels taboo. Madani's 'Shit Moms' are not necessarily doing a bad job of parenting, but they're not finding it a breeze, either. They represent real people, struggling through chaos, feeling exhausted and spread too thin, but, ultimately, doing their best.

British artist Jadé Fadojutimi's paintings are not only thrilling for their vigour and energy, but also because she works with paint in a visual language that is remarkably new. Many times over, since the birth of photography, painting has been declared dead – whether proclaimed obsolete as it became untethered from the task of representation, rejected as limited and outdated as a means of relating to everyday life, or maligned as simply having exhausted its repertoire of

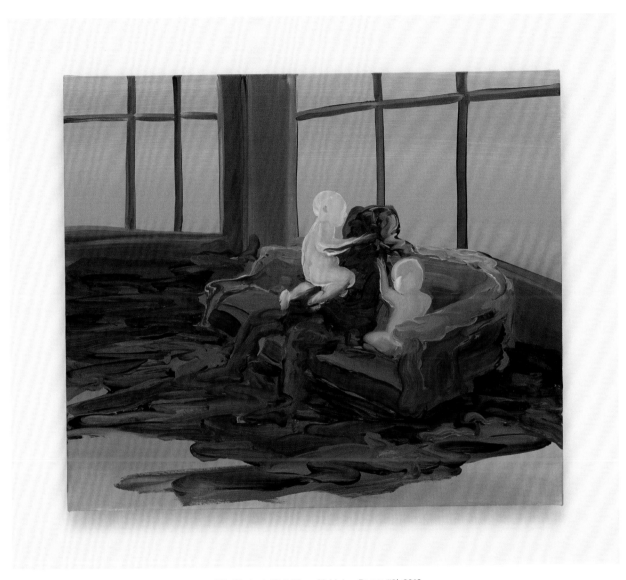

Tala Madani, *Shit Mom (A Living Room #2)*, 2019

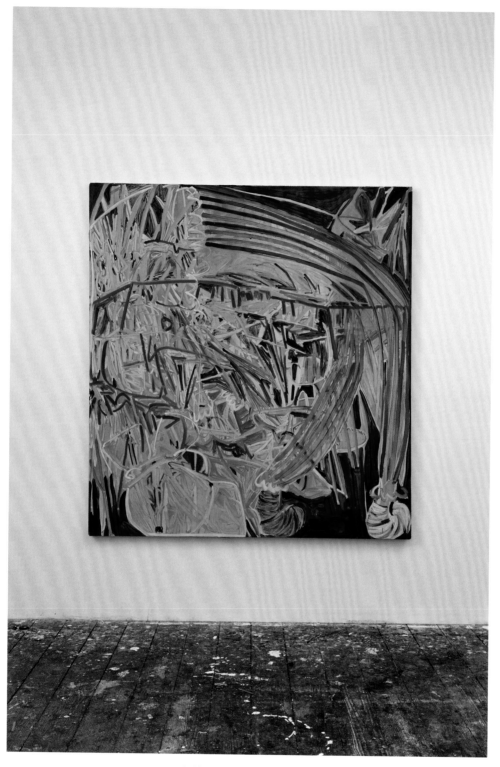

Jadé Fadojutimi, *Clumsy*, 2017

forms and expressions. Yet artists continue to innovate within their chosen medium.

Like many abstract painters before her, Fadojutimi does not work with colour and form for the sake of it, but rather to express complex themes and emotions. For her, painting is a language that allows her to approach 'the indescribable: moments that enthral and challenge me with a stream of questions that continue to build over time. These include feelings of belonging, struggle, pleasure, conflict – aspects of reality which cannot be fully articulated through language.'[1]

On one level, her painting *Clumsy* is a simple experiment with palette. Fadojutimi had purchased two new oil paint pigments – rose madder and lapis lazuli – and decided to work with them together in this painting. She completed the painting in one sitting from 11 p.m. to 5 a.m., just before her works were due to leave the studio for a major solo exhibition. This may seem last-minute or impulsive, but Fadojutimi's paintings build in her mind over long periods of rumination and then occasionally come out in a flash. Drawing inspiration from events in her day-to-day life, *Clumsy* was the result of a 'clumsy' week in which the artist lost her purse, among other mishaps.

While it may seem like an entirely abstract composition at first sight, closer inspection reveals two socked feet and perhaps an extended leg. Using a distinctive technique of washes, gestural marks and inscriptions with the back of the paintbrush, Fadojutimi buries a personal lexicon of imagery within her paintings: the outlines of objects that are important to her. In some ways, her process is intuitive: as paint is applied to the canvas, each mark responds to the last. This approach culminates in a visual effect that is both exceptionally mysterious and strangely communicative. As Fadojutimi describes, 'I have this quite perverse relationship with paint. I really envy it. It can talk better than I do.'[2]

As long as artists continue to choose painting as a means of expressing themselves, it remains very much alive and kicking. And while certain subjects may have been well-covered in the past or may seem over-saturated in the present, there is always something new to say. History and innovation do not necessarily stand opposed, and the artists in this chapter prove that when you think you've seen it all before, often it is worth taking another look.

Has it all been done before?

Zanele Muholi, *Flesh II*, 2005

Ever noticed how throughout art history there seem to be so few women artists, but so many paintings and sculptures of female nudes? This highly sexualised view, which is often called the 'male gaze', has informed representations of women for centuries. It is only recently that artists who do not identify as male have had the means to represent themselves and their communities. In their hands, a very different understanding of womanhood emerges: one that is far more diverse, nuanced and reflective of lived experience.

South African photographer Zanele Muholi prefers to be understood as a 'visual activist', rather than an artist. In 2002, Muholi co-founded the Forum for the Empowerment of Women, an organisation supporting and empowering Black lesbians, and later went on to found Inkanyiso, a platform for queer and visual activism.

Flesh II is an intimate portrait of a voluptuous Black person in the bath. Her body fills the frame, while her head is cropped out so her identity is obscured. The perspective implies a level of trust between the photographer and subject, reflecting the fact that Muholi photographs their own community. Here, we are presented with a body that is underrepresented by the media. The woman in the photograph does not pose for the viewer, rather she is turned to the side and reaches between her legs, washing or perhaps pleasuring herself. She is captured in a deeply personal moment, that casts her audience as voyeurs; we are witnessing something that is about her and not us. Her exposed flesh suggests vulnerability, but there is a tenderness to the image that instead gives over a sense of strength and dignity in the way she commands the space of the image. The female nude 'bather' is a historic subject approached here from a different perspective.

Sonia Boyce, one act from *Six Acts*, 2018

In 2018, Manchester Art Gallery invited British artist Sonia Boyce to make new work responding to the museum's eighteenth- and nineteenth-century collections. She decided to work with a variety of museum staff, including event programmers, gallery invigilators, conservators and cleaners, to explore the ways that gender and sexuality were circumscribed by the works on view. Their discussions focused in on John William Waterhouse's *Hylas and the Nymphs* (1896), a painting showing a mythological scene of Hercules's male lover, Hylas, being beckoned to a watery demise by six young, bare-chested nymphs in a lily-covered pond.

Boyce uncovered 'a discomfort among the staff themselves, not only in the conversations that they've been having publicly with visitors to the gallery, but about an overarching narrative: first, a sense of the idealised female form, but also the female figure as the embodiment of death or something deathly, which is a very old trope.'[3] The collective decision was taken to temporarily take the painting off view. In its place, a sign was put up explaining that a temporary space had been left 'to prompt a conversation about how we display and interpret artworks,' followed by a series of questions around how we relate to the past.[4] Visitors were invited to leave their responses via notes affixed to the wall.

The reaction was largely one of outrage, on the wall, on social media and in the press. It was seen as an act of censorship and decried as political correctness gone too far in the wake of the #MeToo movement. In fact, Boyce was actually making a point about who decides what gets shown in museums and galleries. In inviting a much wider pool of people into the curatorial process, she drew attention to the institutional mechanics behind artistic judgements that so often go on behind the scenes in ways that are not seen or questioned. After only seven days, Manchester City Council intervened to return the painting. The strength of public reaction showed that for many, the past is sacrosanct. But by fossilising history and making it untouchable, this nostalgic impulse has far-reaching ramifications for the present. For Boyce, 'the past never sits still and contemporary art's job is increasingly about exploring how art intersects with civic life.'[5]

Clare Twomey, *Time Present and Time Past,* **2016**

Upon encountering British artist Clare Twomey's work *Time Present and Time Past*, you could be forgiven for thinking it was not yet finished. For this project, Twomey turned London's William Morris Gallery into a studio. Each day, a master-craftsperson would train a member of the public in the skills required to embellish a tile with gold enamel. On a workbench in the centre of the gallery, 130 ceramic tiles were laid out spanning 3 × 4m (10 × 13ft). Together, they formed a panel decorated with an elaborate wallpaper pattern by the celebrated nineteenth-century designer and champion of the arts and crafts movement, William Morris.

Anyone could sign up and take part, regardless of experience, and free of charge. Throughout the exhibition, sixty-eight apprentices spent a day learning to recreate Morris's design in 22-carat gold enamel. Other visitors to the gallery could witness this transfer of skills taking place as an active process and a kind of performance. As Twomey puts it: 'You will see what begins as a nervous enterprise to what we know will become a confident set of actions in the apprentice's hands by the end of the day.'[6] The process of learning a skill passed down over generations was placed front and centre and given precedence over the object itself. After the exhibition, the tiles were distributed to various collectors who had crowd-funded the project, but the experience and the skills gained stayed with the participants.

Time Present and Time Past reminds us that objects are invested with time, and each contains the story of its making. In following Morris's pattern, each participant was also learning indirectly from Morris himself and paying homage. 'Their practice of laying down skill, of seeing the skill in their hands', Twomey notes, 'gives more voice to the original work.'[7] It is fitting that the pattern selected was *Chrysanthemum* (1877), a traditional symbol within much of Asia for birth and rebirth. With each tile, the craft-making skills Morris so espoused are brought to life once again.

166 Has it all been done before?

Ana Mazzei, *Êxtase* from the series *Garabandal: Morte, Ascensão e Êxtase*, 2015

Brazilian artist Ana Mazzei's *Garabandal* works grew out of a fascination with what it means to have a vision. The artist investigated altered states of consciousness that are said to occur during religious ecstasies, research that led her to the Garabandal apparitions of 1961–5, where four schoolgirls in Northern Spain were said to have been visited by the Virgin Mary. Documentation of the phenomenon shows the girls kneeling, heads tilted back, gaze fixed upwards with broad smiles illuminating their faces. It is a posture Mazzei recognised from Renaissance and Baroque religious paintings by such greats as Caravaggio and Gentileschi, but also images and descriptions of women experiencing 'hysteria'.

Mazzei's works recognise the power that certain postures hold: they recur time and again, supporting the body when all sense of control or awareness appears to be absent. *Êxtase* ('Ecstasy') is formed of wooden supports assembled into an armature, and invites viewers to step into its frame and assume this ecstatic pose themselves. While we may be accustomed to observing saints in these poses on the walls of museums and churches, we ordinarily look upon them from a standing or seated position as something that happens to other people. Mazzei invites us to engage our physical experience within the art gallery, rather than focus exclusively on the visual at a safe distance. She explains, 'I realized that the spiritual and the body are connected through positioning, the mind flows through the body and putting yourself in a certain position can lead to a transformation.'[8]

In participating in *Êxtase*, visitors are offered the chance to test out this hypothesis for themselves. When we alter our point of view and our relationship with our bodies, how does our mental state shift? In this sense, the work is an experience as much as it is a sculpture. Yet, it is also a performance. In activating it, the participant embodies the posture for others to observe, and effectively takes the stage.

Celia Hempton, *Seb, France, 3rd June 2014,* 2014

In the European painterly tradition, life drawing has formed the basis of artists' academic training for centuries. British artist Celia Hempton brings this foundational practice into the twenty-first century with her *Chat Random* series of portraits. Using the online social networking platform, chatrandom.com, Hempton sources her subjects from around the world through virtual chance encounters. The website randomly connects users via video chat, enabling both to skip ahead to the next connection as and when they please. Ostensibly a site for making friends across the globe, it has mostly come to be used for anonymous sexual interactions.

Hempton works by scrolling the site on her laptop, with a small canvas of identical dimensions to her screen positioned beside it. When she finds an image she wants to paint, she begins a conversation, typing with one hand and painting with the other. The resulting paintings hinge on the length of the encounter, as the artist paints her subjects only as long as they agree to stay on screen. As such, some of the portraits in the series are more heavily worked, while others appear sketchy and fluid.

Seb, France, 3rd June 2014 suggests the vigour of trying to capture an image quickly – possibly under the constraints of a poor internet connection. 'Seb' hides his face from view, his bare torso bathed in the blue light of his computer screen. It seems he only had limited patience for this exercise and likely had other goals in mind, yet Hempton's loose and expressive brushstrokes offer a rich materiality. In her gaze, what might be thought of as one of the darker recesses of the internet is humanised as another lonely person hiding behind a screen looking to satisfy their desires.

Has it all been done before?

Katie Paterson, *First There is a Mountain*, 2019

First There is a Mountain is a participatory artwork. In the classic summertime tradition of building sand castles with buckets and spades on the beach, British artist Katie Paterson designed a special set of five stacking buckets, each one a precise scale model of a mountain from a different continent: Mount Kilimanjaro (Africa), Mount Shasta (North America), Mount Fuji (Asia), Stromboli (Europe), and Uluru (Australasia). From March to October 2019, the work toured the UK taking place almost weekly, each time hosted by one of twenty-five coastal art venues, from the Scilly Isles off the southern coast to the Outer Hebrides in the very north.

Each event (all staged on a local beach) began with the reading of a specially commissioned text by a celebrated writer, scientist or geologist, ruminating on the relationship between the work and the specificities of the place in which it was being shown. Children and adults were then invited to use fifty sets of the pails to play and build sand mountains on the beach. Together, visitors contributed to create an incremental land artwork, in the tradition of a strand of conceptual art of the 1960s and 1970s that saw artists making ephemeral works from natural materials. While it may seem like all fun and games, this miniature mountain range represents what the artist describes as 'a fast-forwarding of geological history being played out with people's hands'.[9]

All that remains now of the work are the experiences of its participants, and a free-to-download anthology of texts and images online. Paterson went to great lengths to ensure each bucket was 100 percent compostable, creating them entirely from fermented plant starch. At the end of the tour, each pail was shredded and composted by the National Trust, aptly contributing to another natural cycle of regeneration: the pails returning to nourish plant-life from which they had been formed. As Patrick Barkham, one of the contributing authors, wrote for the work, 'As we build our mountains, we remember that our labours are ephemeral, our lives are short and everything must change.'[10]

Has it all been done before?

What now?

What now?

What now?

What now?

What now?

What now?

What now?

What now?

What now?

What now?

What now?

What now?

What now?

What now?

At a time when 'fake news' abounds, it is now clearer than ever that whoever controls the media controls the conversation. In the wake of the brutal killing of George Floyd by police in the United States in May 2020, many people are now coming to learn what many others have known all too well: that, in much of the world, today's media landscape is filtered through a predominantly white perspective. The narratives and stories around Black people are often presented in ways that are racist and one-dimensional or are not reported at all. This means the news cycle perpetuates negative stereotypes enabling racial injustices, with profoundly damaging results for both people of colour and society as a whole. It has fallen to victims and bystanders to set the record straight by capturing footage on their camera phones – but what if there was another way?

American artist Kahlil Joseph offers an alternative with his news platform, *BLKNWS*. The work is a video collage of found clips ranging from news segments and archival footage to music videos and internet memes, alongside anchored news reports. YouTube clips are interspersed with stand-up comedy, powerful musical interludes, commercial idents and talking heads. The hierarchy of information is levelled; for example, coexisting together are a news report on the opening of an exhibition by artist Kara Walker, a powerful clip from an interview with Maya Angelou and a video of a man singing his child to sleep over the phone. The work is presented on two screens hung side-by-side, and the playback on each slips in and out of sync, informing and inflecting the tone of the other. As such, the notion of a singular viewpoint is disrupted and rejected. Speaking about the work, Joseph has said: 'I call *BLKNWS* conceptual journalism – I think anything can be news, given context. That's why there are two screens. Things immediately have context once you start pairing them with something.'[1]

The interplay between the screens of *BLKNWS* creates a certain dynamism, and the careful juxtaposition of different footage, imagery, sound and text makes for a layered and rousing narrative.

The overall effect is deeply moving and emotionally charged, gaining momentum as the images accumulate. Joseph's reportage of racial injustices and harsh truths is tempered with portrayals of Black excellence, love and resilience. What emerges is a complex and uplifting portrait of what it means to be Black in America today. Originally conceived as a pitch to cable networks for a real-life news programme, *BLKNWS* demonstrates how our media could be so much more creative and reflective of all the voices that collectively make up who we are.

And there is much work still to be done. In all aspects of life, the legacies of slavery and colonialism continue to affect the lives of people of colour, whether through income inequality, racial profiling or the disproportionate effects of the Covid-19 pandemic, to give just three examples. There remain many racist and colonial institutional structures still to dismantle before we can rebuild. In the summer of 2020, as rallies in support of the global Black Lives Matter movement gathered, controversial public monuments in many of the world's cities became symbols of the need for change. In New York, a bronze statue of Theodore Roosevelt at the entrance to the Museum of Natural History which depicts Black and Indigenous people as subjugated became the site of protest and was later removed. In Bristol, a sculpture of Edward Colston, a seventeenth-century merchant involved in the Atlantic slave trade, was toppled by protesters and pushed into the nearby harbour. These were monuments that had long been understood as 'problematic', and yet widely overlooked as part of the urban landscape. In 2020, the inherent racism of continuing to idolise icons of a shameful past was brought to a wider public consciousness.

Against this backdrop, a work on display as part of the Biennale of Sydney by Nicholas Galanin (Yéil Ya-Tseen) stands out. *Shadow on the Land, an excavation and bush burial* presented an archaeological dig that sought to unearth the shadow cast by a nineteenth-century bronze statue of Captain James Cook in Sydney's Hyde Park. A captain in the British Royal Navy,

Kahlil Joseph, *BLKNWS*, ongoing two-channel fugitive broadcast, 2018–ongoing

BREAKING

BN Kenyan Court Blocks China-Backed Power Plant on Environment Groun

ent activism. She is known for having initiated the school strike for climate movement that formed in Novem

BLKNWS
Cori Gauff, 15, Stuns
Venus Williams at Wimbledon

EMANCIPATED SPACE.

This message is brought to you by

BLKNWS

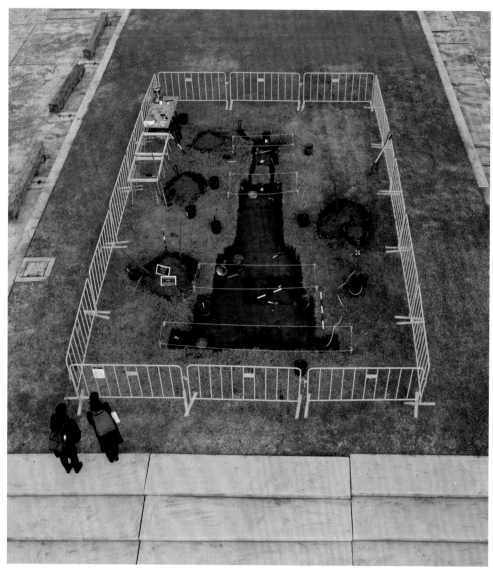

Nicholas Galanin, *Shadow on the land, an excavation and bush burial*, 2020

Cook is famed for having 'discovered' the land now commonly known as Australia in 1770, as well as New Zealand, Tonga and a number of other Pacific islands. With the 250th anniversary of Cook's voyage looming, Galanin's work takes on this one-sided framing of history, where narratives of 'discovery' are told from the settler's point of view. Framing the encounter in this way erases the presence of Indigenous communities, suggesting a smooth annexation of uninhabited land that was there for the taking: a convenient myth that obscures a much darker truth. As an Alaskan artist of indigenous Tlingit and Unangax̂ heritage, Galanin sees the monument's shadow as a symbol of the shadow cast on Indigenous or Aboriginal lands globally. For him, it is 'an embodiment of the shadow of greed, pollution, and destruction cast on the land by corporate capitalist colonisation and settlement.'[2]

In 'excavating' the shadow it has cast and effectively removing it from the land, Galanin also creates a hole the perfect size to bury the monument itself. As the title suggests, this is both a site of extraction and deposit, a place of cleansing and of laying to rest. In using the language of archaeology, the artist adopts a framework that has long contributed to erasing living Indigenous cultures as belonging to the past, and uses it to imagine a time where colonising mythologies can be relegated to the past instead. Galanin asks us to question who these monuments serve, and who they hurt and oppress in the process? What must we let go, what must we acknowledge, what must we destroy – so we can begin again?

In the third decade of the twenty-first century, we face pressing issues of racial injustice, growing inequality, the devastating effects of a pandemic and an ongoing climate emergency. It can often feel overwhelming. Yet there has been courage, grace and hope amidst tragedy in these unprecedented and testing times. Today's artists continue to find ways to bring truths to light, challenge assumptions, encourage connection and offer solace.

Jennifer Lyn Morone, *Jennifer Lyn Morone™ Inc.*, 2013–ongoing

They say if you can't beat them, join them. In 2013, American-born artist and design researcher Jennifer Lyn Morone heeded that advice. Frustrated with how large companies profited from her personal data, she decided to become a corporation herself and claim back control. She incorporated herself as 'Jennifer Lyn Morone™ Inc.' in the state of Delaware, and as such the company has a right to claim its data as property. In the US (as in many parts of the world), corporations enjoy many more rights than ordinary citizens, such as tax breaks and limited liability.

Re-contextualising herself as a corporate entity opened up various possibilities for Morone to monetize her assets and use the legal container to attempt to protect her data as property. Indeed, corporations survive by constantly exploring new revenue streams and, so too, *JLM™ Inc.* sought to maximise value derived from Morone's person, skills, services and potential. As founder, CEO, shareholder and product, she has created promotional video artworks and made her data available for purchase in the form of bank statements, medical records, lifestyle information, digital content and much else besides. She has also trademarked her smile, gait and image, and sold her future potential as shares, as well as marketed perfumes generated from her pheromones and diamonds produced from her hair.

While this may sound like a farce, it is a sobering fact that this is not a speculative exercise, but a genuine life project. It may be absurd, but it is entirely legitimate and possible within the prevailing systems of capitalism. Of course, it is also a wry protest against the power wielded by corporations, and the lack of rights we possess as individuals over our personal information and the profits it generates. In Morone's words: 'I climbed in the suit of the enemy to use their tools and loopholes to try to turn the tables in our favour.'[3]

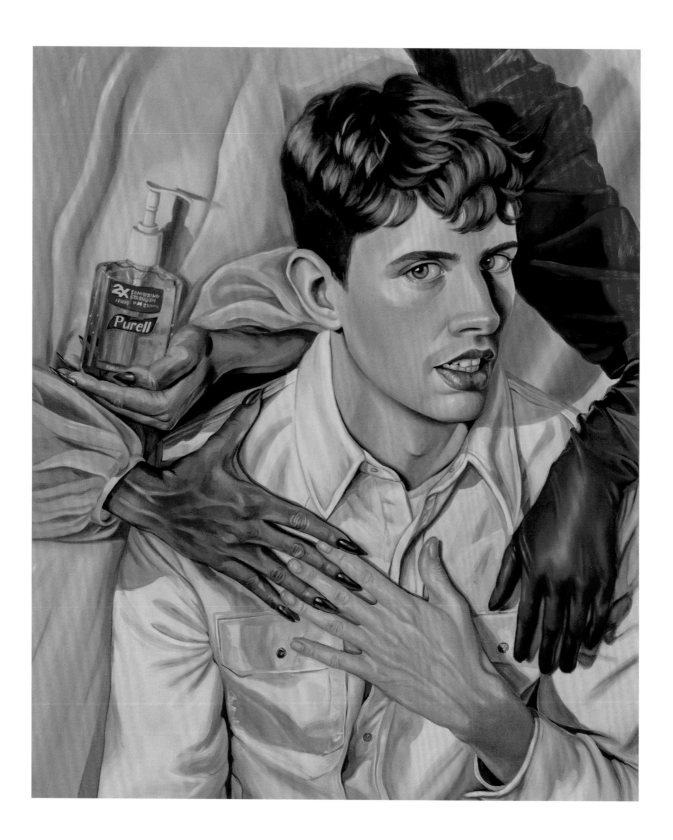

What now?

Chloe Wise, *Tormentedly Untainted*, **2019**

There is something familiar about Canadian artist Chloe Wise's paintings. With the laboured cool of the subjects' poses, and the rich detail applied to their clothing, they recall high-end fashion advertising. And yet, if this is an advert, it seems to be for the unlikely product of Purell hand sanitiser.

Tormentedly Untainted is a captivating work because it feels like it is painted in a language we understand, yet it is so hard to figure out what on earth is going on. A young man locks fingers with what seems to be an older woman with a brilliant blue manicure, although it is hard to tell since whoever the hand belongs to is cropped out of the painting. The gloved arm of a third person, also cropped from view, drapes over his shoulder. In this context, it could just as easily be a satin glove as a rubber glove. There is no way of knowing.

The title suggests a longing at play here, as if there is a frustrated desire to be tainted, something which the sanitising properties of Purell forbid. The figures to whom the gloved and manicured hands belong seem to be protecting the man, but it may well be against his will. Certainly, this tension is visible within the painting: in the look on his face; in the apparent weight of the gloved hand on his shoulder; and the pressure of the index finger, with its sharply pointed blue nail, over his.

For this body of work, the artist assembled some of her friends who were strangers to each other in group portraits and asked them to 'act natural'. Wise was keen to get across what she describes as 'the fragility of our shared semblance of order.'[4] Born in the nineties, she grew up as a digital native and the coded visuals of the internet have informed much of her work. Wise elucidates: 'When, for a LinkedIn or Tinder profile pic, you crop yourself out of a group photo, and the fragmented hands of those whose arms were around you remain attached, now severed, to your shoulder – I always thought that was such a beautiful visual reminder of the potential for, even in togetherness, the faint, insidious threat of isolation.'[5]

For all its references to sanitiser, connection and isolation, it is all the more surprising that this was painted months before the outbreak of Covid-19.

What now?

Sin Wai Kin fka Victoria Sin, *If I had the words to tell you we wouldn't be here now*, 2019

'I want to use words to tell you that I am more than you could say, because you have not been given the words to describe how multiple your selves are,' articulates Sin Wai Kin in this performance work. The protagonist describes a longing to communicate, amid the failings of language to accurately represent the multiplicity of what it means to be human.

This richly poetic treatise is relayed via voiceover which Sin, magnificently decked out in full drag get-up, either mouths along to or allows to play as though the voice of their subconscious. In tandem, a live instrumentalist collaborates to express certain phrases the narrator cannot convey in words. The duetting musician is selected according to the context of each performance. In Taiwan, the work was performed with a traditional string instrument called a *pipa*, in Italy on a type of flute known as a *traverso* and in France a local accordion player executed the music. Each name in the narrative is replaced with a musical note, a move that feels both more evocative and less confining than language could be. As the protagonist describes, 'naming is an act of mastery'; in defining something, we restrict it and tame it into the confines of the definition we have given it. In this way, language circumscribes things and can only ever be an approximation of their true nature. Thus we establish categories of gender, race and nationality that reduce us to descriptors and can act to define us in violent and constricting ways.

In delivering this monologue via the drag tradition of lip-sync, dressed in the trappings of an exaggerated femininity with a painted mask of make-up, Sin demonstrates how identity can be constructed and performed. In assuming their drag persona, they show that identities are multiple and fluid. Our possibilities are so much greater than we can contain with words. Art can intervene where language fails us.

UV Production House (Joshua Citarella and Brad Troemel), *Air BNB Housing Solution: Remain On Your Lower East Side Apartment's Fire Escape in a Hanging Tent while Guests Pay Off Your Month's Rent*, **2016 and** *A Bubble*, **2016**

Being an artist these days is expensive. There are significant overheads to maintaining an artistic practice: studio rental, material costs, specialist equipment, storage fees and so on – and that's not including the cost of an art education. Enter Joshua Citarella and Brad Troemel, two American artists who decided to build a more equitable model of artistic production, sales and distribution.

Their project *Ultra Violet Production House* began life as an online store on the popular sales platform, Etsy. When they had new ideas for artworks – rather than creating objects in real life, which would cost money to make, house and store, with no guarantee of purchase – they used Photoshop to create digital composite images of what they had in mind. These hypothetical works were uploaded to the store with artwork descriptions and prices. Although the works did not technically exist, the experience of online shopping was the same. However, upon purchasing a piece, collectors would have the components shipped directly to their address via Amazon, and receive a detailed set of fabrication instructions so that they could assemble it themselves. As Citarella describes, 'It's a location-independent, post-studio practice. My collaborator Brad Troemel and I can ostensibly do this project from a Starbucks or a WiFi-enabled McDonalds – anywhere that we can sit with our computers.'[6]

There are products to suit all budgets, and many engage wryly with contemporary issues. Examples include a hanging tent so that you can camp on your fire escape while renting out your flat on Airbnb in order to cover your rising rent; an unbreakable phone case made from ballistics gel; a compostable compost bin; and an oversized bubble. And of course, all purchases come with a certificate of authenticity, but DIY skills are the buyer's own.

Alex Cecchetti, *Walking Backwards*, 2013–ongoing

Italian artist Alex Cecchetti's *Walking Backwards* is a performance especially for you and you alone. For thirty minutes, it is as though time has slowed to allow you to appreciate the world in a new and fantastical way. Walking slowly backwards through a garden of extraordinary beauty, you are gently led by a guide behind you, who regales you with enchanting tales of the various trees and plants that surround you. Spoken softly in your ear, these are stories that convey the wonders of botanical life, from the history of the garden to marvellous and little-known facts about the different plant species.

The simple shift in perspective of walking backwards is integral to the experience. 'When we walk backwards,' Cecchetti explains, 'we leave the future behind, and the past presses in the distance in front of us, on the horizon.'[7] Things come into view suddenly and surprisingly, and linger there as they fade into the distance. It is a form of looking that feels cinematic, but it is far from passive. In allowing yourself to be guided, each step is an act of trust. Unable to see where you are going, you become more aware of your body, and the garden's sounds and scents. You are invited to pause and smell a flower, feel the cool underside of a leaf or appreciate the unusual texture of a particular bark. And there is a remarkable intimacy in sharing these discoveries with a stranger.

Walking backwards also activates the imagination. You learn of things before knowing how they look. In Cecchetti's words, 'if a branch touches our back, or a flower gently caresses our hand, suddenly it will become apparent that images do not depend on light ... we dream with our eyes closed, don't we?'[8] While some artists embrace the future or technology, others like Cecchetti show us that there is poetry in the most simple acts, so much wonder to be found in nature and tenderness to be discovered in moments shared.

What now?

Shezad Dawood, *Leviathan Legacy: Part 1*, 2018

The *Leviathan* universe conjured up by British artist Shezad Dawood is a huge project, spanning a ten-part film cycle, paintings, sculpture, commissioned talks and research, and a virtual-reality trilogy. Produced in collaboration with oceanographers, marine biologists and neurologists, these imaginative forays are premised entirely on scientific research.

The immersive experience, *Leviathan Legacy: Part 1*, is set 150 years in the future. You put on the VR headset, grab the controllers, and suddenly you find yourself on the beach at night. A luxury marina is out of reach to your right, a digital tablet newspaper is discarded on the ground, and a flying car passes overhead. If you look down at your hands, you may not recognise them as your future self has evolved into a post-human cyborg. Looking out towards the ocean, you are beckoned into the water by a mysterious voice calling out 'Step in, the water's warm…'. That voice, it turns out, belongs to a giant telepathic Louisiana red swamp crayfish, who happens to be a wise-cracking New Yorker – of course! And so begins a strange underwater journey with this jovial crustacean as your guide.

Along the way you'll encounter huge jellyfish and lionfish, mutated to become outsized as a result of rising sea levels and calcification of the oceans. You'll see a hybridised coral reef that has survived only as a result of genetic engineering, to help it withstand the effects of pollution.

As events unfold, you'll see that it is the sea life that's in control, not you. As humans, we often act without thought for other species or the environment; Dawood's world reminds us that this kind of anthropocentric thinking will not serve us well. As we gaze into a dystopian future, and remove our headsets into an uncertain present, we are left with the knowledge that the time for change is now.

What now?

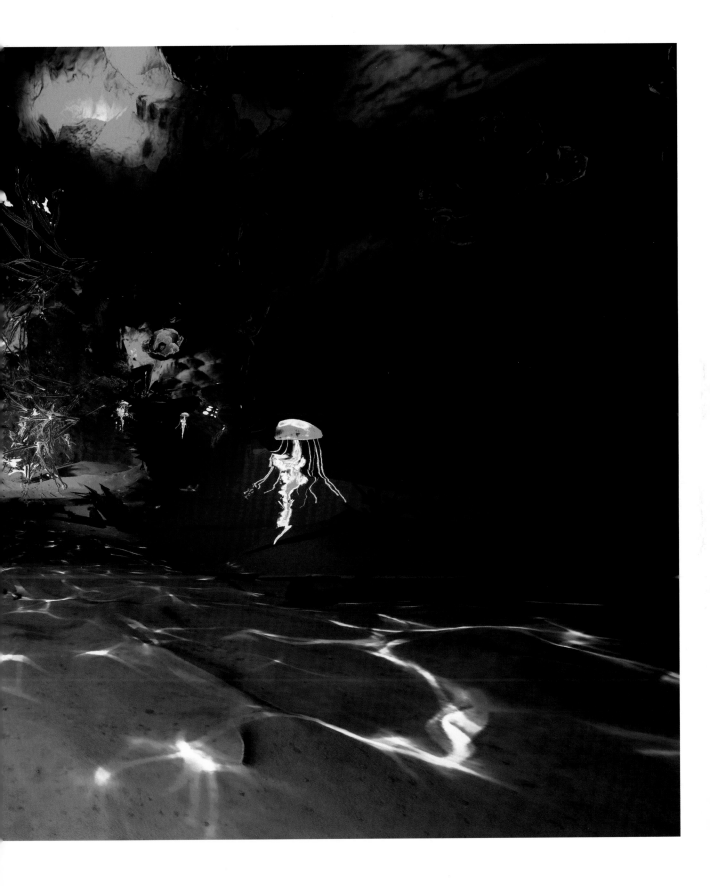

References

Notes

What is Contemporary Art?

1 Mark Rothko quoted in Elderfield, John (Ed.), *Visions of Modern Art: Painting and Sculpture from the Museum of Modern Art*, New York: The Museum of Modern Art, 2003, pp. 221–2.

2 Martine Gutierrez quoted in Rawley, Lena, 'This Artist Thinks Gender Is a Drag', *The Cut*, 9 February 2017, https://www.thecut.com/2017/02/martine-gutierrez-thinks-gender-is-a-drag-new-film.html (accessed 7 January 2020)

3 Lévi-Strauss, Monique, 'Oral history interview with Sheila Hicks, 2004 February 3-March 11', *Archives of American Art*, 2004, https://www.aaa.si.edu/collections/interviews/oral-history-interview-sheila-hicks-11947#transcript (accessed 13 January 2020)

4 Lynette Yiadom-Boakye quoted in *Lynette Yiadom-Boakye: Fly in League with the Night* [exhibition guide], Tate Modern, 2020, https://www.tate.org.uk/whats-on/tate-britain/exhibition/lynette-yiadom-boakye/exhibition-guide (accessed 31 January 2021)

5 Ibid.

6 Vaiva Grainytė quoted in Halperin, Julia, 'It's Hard to Make Good Art About Climate Change. The Lithuanian Pavilion at the Venice Biennale Is a Powerful Exception', *artnet*, 10 May 2019, https://news.artnet.com/exhibitions/lithuanian-pavilion-1543168 (accessed 8 February 2020)

7 Walead Beshty quoted in 'Walead Beshty: About the Artist', Whitney Biennial 2008, 2008, https://whitney.org/www/2008biennial/www/index.php?section=artists&page=artist_beshty (accessed 3 February 2020)

Where did it come from?

1 Board statement quoted in Naumann, Francis M., *The Recurrent, Haunting Ghost: Essays on the Art, Life and Legacy of Marcel Duchamp*, New York: Readymade Press, 2012, p.72

2 Yoshihara Jirō quoted in Tiampo, Ming, 'Create what has never been done before!', *Third Text*, 21:6, 2007, p. 689

3 Atsuko Tanaka quoted in Namiko Kunimoto, 'Tanaka Atsuko's "Electric Dress" and the Circuits of Subjectivity', *The Art Bulletin*, Vol. 95, No. 3 (September 2013), p. 480

4 Lygia Clark quoted in Butler, Cornelia H. and Pérez-Oramas, Luis, *Lygia Clark: The Abandonment of Art, 1948–1988*, New York: The Museum of Modern Art, 2014, p. 160

5 Sam Gilliam quoted in Jones, Kellie, *EyeMinded: Living and Writing Contemporary Art*, Durham and London: Duke University Press, 2011, p. 370

6 Gilliam, Sam, 'Solids and Veils: Sam Gilliam, with Annie Gawlak', *Art Journal*, Spring, 1991, https://www.kleinart.com/html/gilliam-articles-1991.html (accessed 3 March 2020)

7 Ibid.

8 Carolee Schneemann in McPherson, Bruce R. (Ed.), *More Than Meat Joy: Performance Works and Selected Writings*, New York: McPherson & Co, 1979, p. 235

9 Schneemann, Caroleee, 'The Obscene Body/Politic', *Art Journal*, Vol. 50, No. 4, Censorship II (Winter, 1991), pp. 31–3

10 Carolee Schneemann quoted in 'Carolee Schneemann by Coleen Fitzgibbon', *BOMB*, 15 July 2015, https://bombmagazine.org/articles/carolee-schneemann/ (accessed 28 February 2020)

11 Nam June Paik quoted in *Nam June Paik: Exposition of Music, Electronic Television*, ed. Susanne Neuburger, Vienna: Museum Moderner Kunst, Stiftung Ludwig Wien, 2009, p. 65

12 Hatfield, Dr Jackie, 'Interview with Tina Keane', *REWIND | Artists' Video in the 70's & 80's*, 2 March 2005, http://www.rewind.ac.uk/documents/Tina%20Keane/TK505.pdf (accessed 29 October 2020), p. 8

13 Tina Keane quoted in MacRitchie, Lynn, 'Transposition (Lynn Macritchie On Tina Keane)', *Mute*, Vol. 1, No. 4 – Analogue City, 10 March 1996, https://www.metamute.org/editorial/articles/transposition-lynn-macritchie-tina-keane (accessed 29 October 2020)

14 Michael Craig-Martin quoted in *Michael Craig-Martin: Landscapes*, Dublin: Douglas Hyde Gallery, 2001, p. 20

Does it have to mean something?

1 Bruguera, Tania, 'Introduction on Useful Art', 2011, https://www.taniabruguera.com/cms/files/2011-_tania_useful_art_presentation.pdf (accessed 13 March 2021)

2 Reynolds, Laurie Jo and Eisenman, Stephen F., 'Tamms Is Torture: The Campaign to Close an Illinois Supermax Prison', *Creative Time Reports*, 6 May 2013, https://creativetimereports.org/2013/05/06/tamms-is-torture-campaign-close-illinois-supermax-prison-solitary-confinement/ (accessed 12 May 2020)

3 Tania Bruguera quoted in 'Activist Art', Tate Art Terms, https://www.tate.org.uk/art/art-terms/a/activist-art (accessed 12 May 2020)

4 'Barbican Meets : John Akomfrah', Barbican Centre, 20 October 2017, https://www.youtube.com/watch?v=rQO2EObK_UI&t=4s (accessed 12 May 2020)

5 'Judi Werthein: "We Need to Pussify the Art World"', TateShots, 12 November 2019, https://www.tate.org.uk/art/artists/judi-werthein-11096/pussify-art-world (accessed 14 April 2020)

6 From *Facial Weaponization Communiqué: Fag Face* by Zac Blas, 12 January 2013, https://vimeo.com/57882032 (accessed 18 March 2020)

7 Jenny Holzer quoted in 'REJOICE! OUR TIMES ARE INTOLERABLE: Jenny Holzer's Street Posters, 1977–1982' [press release], http://www.aldenprojects.com/2016/12/rejoice-our-times-are-intolerable-jenny-holzer.html (accessed 3 June 2020)

8 Keg de Souza quoted in *20th Biennale of Sydney: Guide*, Sydney: Biennale of Sydney, 2016, p. 205

9 Casiuc, Carola, 'I see practice and the encounter with the living body as producing theory' [interview with Alexandra Pirici], Revista-ARTA, 4 May 2017, https://revistaarta.ro/en/i-see-practice/ (accessed 5 December 2020)

What about how it feels?
1 Goethe, Johann Wolfgang von, 'Roman Elegies VII', *Selected Poetry*, trans., ed. David Luke, London: Penguin, 2005, p. 138

2 Anna Maria Maiolino quoted in Brenner, Fernanda, '"I Allowed Myself to Be Eaten": Anna Maria Maiolino on the Cultural Cannibalism of Brazil', *Frieze*, 18 August 2019, https://www.frieze.com/article/i-allowed-myself-be-eaten-anna-maria-maiolino-cultural-cannibalism-brazil (accessed 16 June 2020)

3 Tatay, Helena, 'Interview | Conversation between Anna Maria Maiolino and Helena Tatay', *CFile*, 29 July 2014, https://cfileonline.org/interview-conversation-anna-maria-maiolino-helena-tatay/ (accessed 16 June 2020)

4 Anna Maria Maiolino quoted in Brenner, Fernanda, op. cit.

5 Ibid.

6 Anna Maria Maiolino quoted in Tatay, Helena, op. cit.

7 Phyllida Barlow quoted in *Phyllida Barlow RA: cul-de-sac* [exhibition guide], The Royal Academy of Arts, 2019, https://royal-academy-production-asset.s3.amazonaws.com/uploads/5e0d9f2a-c800-4578-bd54-cb85a4d01755/PhyllidaBarlow_LOW.pdf, (accessed 3 August 2020), p. 21.

8 Lewallen, Constance, 'Interview with Anish Kapoor, Japan, September, 1990', reproduced in *View*, VII no. 4, 1991

9 Ibid.

Does it have to be so serious?
1 Rose Finn-Kelcey quoted in Brett, Guy and Finn-Kelcey, Rose, *Rose Finn-Kelcey*, London and Birmingham: Chisenhale Gallery and Ikon Gallery, 1994, p.8

2 Adams, Tim, 'Carsten Höller: "It is impossible to travel down a slide without smiling"', *The Observer*, 17 May 2015, https://www.theguardian.com/artanddesign/2015/may/17/carsten-holler-travel-down-a-slide-without-smiling-decision (accessed 22 June 2020)

3 Caillois, Roger, *Man, Play and Games*, trans. Meyer Barash, Urbana and Chicago: University of Illinois Press, 2001, p. 23

4 Honoré, Vincent, 'Carsten Höller: Interview', Tate, 2006, https://www.tate.org.uk/whats-on/tate-modern/exhibition/unilever-series/unilever-series-carsten-holler-test-site/carsten (accessed 22 June 2020)

5 Roman Ondák quoted in Andrews, Max, 'Why are we waiting?', *TATE ETC*, 1 September 2005, https://www.tate.org.uk/tate-etc/issue-5-autumn-2005/why-are-we-waiting (accessed 22 June 2020)

6 Thompson, Mildred, Artist's Statement, c. 1995, http://mildredthompson.org, (accessed 2 August 2020)

Does it matter who makes it?
1 Drucker, Zackary and Ernst, Rhys, *Relationship*, Munich, London and New York: Prestel, 2016, p. 10.

2 Ryan, Hugh, 'In *Relationship*, Artists Zackary Drucker and Rhys Ernst Explore Love in a Time of Transition', *Slate*, 28 July 2016, https://slate.com/human-interest/2016/07/zackary-drucker-and-rhys-ernst-s-relationship-explores-love-of-the-trans-artists.html (accessed 24 August 2020)

3 Hannah Black's open letter reproduced in full in Greenberger, Alex, '"The Painting Must Go": Hannah Black Pens Open Letter to the Whitney About Controversial Biennial Work', *ARTnews*, 21 March 2017, https://www.artnews.com/artnews/news/the-painting-must-go-hannah-black-pens-open-letter-to-the-whitney-about-controversial-biennial-work-7992/ (accessed 12 September 2020)

4 Ibid.

5 Dana Schutz quoted in Kennedy, Randy, 'White Artist's Painting of Emmett Till at Whitney Biennial Draws Protests', *The New York Times*, 21 March 2017, https://www.nytimes.com/2017/03/21/arts/design/painting-of-emmett-till-at-whitney-biennial-draws-protests.html (accessed 12 September 2020)

6 Boucher, Brian, 'Dana Schutz Responds to the Uproar Over Her Emmett Till Painting at the Whitney Biennial' [interview with Dana Schutz], *artnet*, 23 March 2017, https://news.artnet.com/art-world/dana-schutz-responds-to-the-uproar-over-her-emmett-till-painting-900674 (accessed 12 September 2020)

7 'Margaret Wertheim: The Grandeur and Limits of Science' [interview with Margaret Wertheim], *On Being with Krista Tippett*, 23 April 2015, https://onbeing.org/programs/margaret-wertheim-the-grandeur-and-limits-of-science-feb2017/ (accessed 29 March 2020)

8 Cooke, Rachel, 'My art is a form of restoration' [interview with Louise Bourgeois], *The Observer*, 14 October 2007, https://www.theguardian.com/artanddesign/2007/oct/14/art4 (accessed 28 August 2020)

9 Janine Antoni quoted in 'Jane Antoni' [Guggenheim teaching materials] https://www.guggenheim.org/teaching-materials/moving-pictures/janine-antoni (accessed 31 July 2020)

10 Gaetano Pesce quoted in Frizzell, Nell, 'Rear of the year: meet the Italian behind the Turner prize buttocks', *The Guardian*, 30 November 2016, https://www.theguardian.com/artanddesign/2016/nov/30/gaetano-pesce-turner-prize-andrea-hamilton (accessed 26 August 2020)

Where do you draw the line?
1 Chris de Ville quoted in Miller, Marjorie, 'Unmade Bed Exhibit Has London Tossing and Turning', *Los Angeles Times*, 29 November 1999, https://www.latimes.com/archives/la-xpm-1999-nov-29-ca-38545-story.html (accessed 28 September 2020)

2 Julian Schnabel, 'Tracey Emin' [interview with Tracey Emin], *Interview*, Lehmann Maupin, June 2006, p. 102–9, https://www.lehmannmaupin.com/attachment/en/5b363dcb6aa72c840f8e552f/News/5b364ddda09a72437d8ba45e (accessed 28 September 2020)

3 Rea, Naomi, '"Turner Was a Really Raunchy Man": Tracey Emin on Why Her Infamous "My Bed" Is Really Like a J.M.W. Turner Painting' [interview with Tracey Emin], *artnet*, 13 October 2017, https://news.artnet.com/exhibitions/tracey-emin-bed-margate-1115603 (accessed 28 September 2020)

4 Praxis: Delia Bajo and Brainard Carey, 'In Conversation: Andrea Fraser' [interview with Andrea Fraser], *The Brooklyn Rail*, October 2004, https://brooklynrail.org/2004/10/art/andrea-fraser (accessed 4 October 2020)

5 Ruf, Beatrix, 'Representation, Arousal, Violence, Theatricality – All Are Called Into Question By The Artist's Works, Created By Choosing To Always Feel More' [interview with Jordan Wolfson], *Kaleidoscope* 28, Fall 2016, http://alexandershulan.com/wolfson.pdf (accessed 4 October 2020): p. 133

6 Xu Bing quoted in 'A Case Study of Transference' [work description], 1995, http://www.xubing.com/en/work/details/395?year=1995&type=year (accessed 22 October 2020)

7 Maurizio Cattelan quoted in Spector, Nancy, 'Maurizio Cattelan's Golden Toilet in the Time of Trump', Guggenheim Blog, 17 August 2017, https://www.guggenheim.org/blogs/checklist/maurizio-cattelans-golden-toilet-in-the-time-of-trump (accessed 4 July 2020)

8 Eddie Peake quoted in Porter, Charlie, 'Eddie Peake Baffles in Italy', *Fantastic Man*, 26 – Union (Autumn/Winter 2017), http://fiorucciartrust.com/wp/wp-content/uploads/2017/09/FM26-Eddie-Peake-LR.pdf, (accessed 4 July 2020): p. 217

9 Eddie Peake quoted in Giles, Oliver, 'In the studio with Eddie Peake', Prestige, 4 November 2016, https://www.prestigeonline.com/hk/pursuits/in-the-studio-with-eddie-peake, (accessed 4 July 2020)

Can anything be art?
1 Hamish Fulton quoted in '"Hamish Fulton", Part of the series theEYE, Series 2: Painting and Video Art', Films Media Group, 2002

2 Hamish Fulton quoted in http://www.hamish-fulton.com/quotes.txt (accessed 23 October 2020)

3 Eyal Weizman in 'Forensic Architecture', TateShots, 14 September 2018, https://www.tate.org.uk/whats-on/tate-britain/exhibition/turner-prize-2018/forensic-architecture (accessed 17 November 2020)

4 'Turner Prize 2018 shortlist announced' [press release], Tate Britain, 26 April 2018, https://www.tate.org.uk/press/press-releases/turner-prize-2018-shortlist-announced (accessed 13 March 2021)

5 Chan, Dawn, 'Interviews: Christine Sun Kim', *Artforum*, 25 November 2015, https://www.artforum.com/interviews/christine-sun-kim-talks-about-her-exhibition-in-london-56374 (accessed 17 November 2020)

6 Wilk, Elvia, 'Artist Profile: Christine Sun Kim' [interview with Christine Sun Kim], *Rhizome*, 30 October 2015, https://rhizome.org/editorial/2015/oct/30/artist-profile-christine-sun-kim/ (accessed 1 November 2020)

7 Janet Cardiff in '[FLVMoMA] Janet Cardiff on her work "The Forty Part Motet"', Fondation Louis Vuitton, 14 December 2017, https://www.youtube.com/watch?v=sZ5xgKVZNmA (accessed 23 March 2021)

8 Armstrong, Annie, '"There's Something Maniacal About Basic Desires": Ian Cheng on His Gladstone Gallery Show, Artificial Intelligence, and His Fear of Snakes', *ARTnews*, 4 February 2019, https://www.artnews.com/art-news/artists/ian-cheng-gladstone-bob-artificial-intelligence-11825/ (accessed 16 October 2020)

9 Ian Cheng quoted in Bucknell, Alice, 'Ian Cheng: Introducing BOB', *Elephant*, 6 March 2018, https://elephant.art/ian-cheng-introducing-bob/ (accessed 17 October 2020)

10 Farago, Jason, 'An interview with Ian Cheng', *Even*, Issue 4, Summer 2016, http://evenmagazine.com/ian-cheng/ (accessed 16 October 2020)

Has it all been done before?

1 Jadé Fadojutimi quoted in Cohen, Alina, '11 Emerging Artists Redefining Abstract Painting', *Artsy*, 6 January 2020, https://www.artsy.net/article/artsy-editorial-11-emerging-artists-redefining-abstract-painting (accessed 31 October 2020)

2 Jadé Fadojutimi quoted in Epps, Philomena, 'Jadé Fadojutimi: Heliophobia', *Elephant*, 9 December 2017, https://elephant.art/jade-fadojutim-heliophobia/ (accessed 31 October 2020)

3 Sonia Boyce quoted in Luke, Ben, '"At the heart of all this is the question of power": Sonia Boyce on the notorious Hylas and the Nymphs takedown', *The Art Newspaper*, 29 March 2018, https://www.theartnewspaper.com/interview/sonia-boyce-hylas-and-the-nymphs (accessed 21 October 2020)

4 Boyce, Sonia, 'Our removal of Waterhouse's naked nymphs painting was art in action' [reproduction of sign], *The Guardian*, 6 February 2018, https://www.theguardian.com/commentisfree/2018/feb/06/takedown-waterhouse-naked-nymphs-art-action-manchester-art-gallery-sonia-boyce (accessed 21 October 2020)

5 Ibid.

6 'Clare Twomey: Time Present and Time Past', William Morris Gallery, 30 June 2016, https://www.youtube.com/watch?v=mlhCezEziC4 (accessed 29 December 2020)

7 Ibid.

8 Ana Mazzei in correspondence with the author, 6 August 2020

9 Mansfield, Susan, 'Ones to watch in 2019: Katie Paterson, artist' [interview with Katie Paterson], *The Scotsman*, 8 January 2019, https://www.scotsman.com/arts-and-culture/ones-watch-2019-katie-paterson-artist-1423810 (accessed 14 October 2020)

10 Barham, Patrick, 'Portstewart Strand', in Paterson, Katie, (Ed.), *First There is a Mountain: Anthology*, 2019, https://prismic-io.s3.amazonaws.com/ftiam/e55cf3e4-8d0b-4b9c-8428-efe3202ca965_FTIAM-Anthology-v2-spread-lines.pdf (accessed 14 October 2020): p. 57.

What now?

1 Kahlil Joseph quoted in Solway, Diane, 'Kahlil Joseph Is Challenging Representations of Black Life in America', *Surface*, 2 December 2019, https://www.surfacemag.com/articles/kahlil-joseph-challenging-black-life/ (accessed 31 July 2020)

2 Galanin, Nicholas, 'Shadow on the land, an excavation and bush burial' [work description], 2020, https://www.flickr.com/photos/galanin/49817576288 (accessed 17 January 2021)

3 Jindrová, Tereza, 'Jennifer Lyn Morone with Tereza Jindrová: Managing Her Own Life', *Fotograf*, #32 non-work, October 2018, https://fotografmagazine.cz/en/magazine/non-work/interview/terezy-jindrove-s-jennifer-lyn-morone/ (accessed 3 January 2020)

4 Moioli, Chiara, 'The Games We Play: Chloe Wise', *Mousse Magazine*, 2019, http://moussemagazine.it/the-games-we-play-chloe-wise-chiara-moioli-almine-rech-london-2019/ (accessed 13 January 2020)

5 Ibid.

6 Abrams, Loney, 'The Artists Have Been Set Free: Post-Internet Star Joshua Citarella on How the Web Can Disrupt the Gallery System', *Artspace*, 20 December 2016, https://www.artspace.com/magazine/interviews_features/qa/joshua-citarella-on-how-the-web-can-liberate-artists-54460 (accessed 14 December 2020)

7 Alex Cecchetti quoted in FOG Festival [work description], 2019, https://triennale.org/en/events/alex-cecchetti-walking-backwards/ (accessed 29 December 2020)

These references pertain to artists' quotes reproduced in this book and are listed in the order they feature in each text. The emphasis on online sources reflects a year in which libraries have been closed, but hopefully also allows for greater access should you wish to read further.

Index

Index

Picture credits

10 Courtesy of HEART – Herning Museum of Contemporary Art. © DACS 2021

13 Courtesy of the artist and König Galerie, Berlin, London, Tokyo

15 © Martine Gutierrez; Courtesy of the artist and Ryan Lee Gallery, New York

16–17 Tate, presented by Melvin Bredrick, New York with the support of Alison Jacques, London (Tate Americas Foundation) 2018; on long-term loan. © Sheila Hicks

18–19 Courtesy Ota Fine Arts and Victoria Miro © Yayoi Kusama. Additional image details: Room with mirror, LED lights, water pool. 296 x 622.4 x 622.4cm 116 1/2 x 245 1/8 x 245 1/8in

20 Courtesy the Artist, Corvi-Mora, London and Jack Shainman Gallery, New York

22–3 Luca Zanon/Awakening/Getty Images

24–5 © Walead Beshty. Courtesy of the artist, Regen Projects, Los Angeles and Thomas Dane Gallery, London

27 Young-Hae Chang Heavy Industries

31 © Succession Marcel Duchamp/ADAGP, Paris and DACS, London 2021. Photo © Tate

32 © the artist. Photo: akg-images

34 Courtesy 'The World of Lygia Clark' Cultural Association. Photo Marcelo Ribeiro Alvares Correa

36–7 Courtesy Dia Art Foundation, New York. © ARS, NY and DACS, London 2021. Photo: Bill Jacobson Studio, New York

39 © ARS, NY and DACS, London 2021. Photo © Tate

40 © Nam June Paik Estate. Photo © Tate

43 © Tina Keane, Video stills, courtesy England & Co Gallery

45 © Michael Craig-Martin. Courtesy the artist and Gagosian

49 Courtesy: Tamms Year Ten. Photo: Soohyun Kim

51 © Smoking Dogs Films; Courtesy Smoking Dogs Films and Lisson Gallery

52 © Judi Werthein

55 © Meschac Gaba. Photo © Tate

56 Courtesy of the artist

58–9 © Jenny Holzer. ARS, NY and DACS, London 2021. Photo © Tate

60–3 © Keg de Souza

65 © Alexandra Pirici. Commissioned by Manifesta 10 Public Programme. Photo: Sepake Angiama

69–71 © Anna Maria Maiolino. Courtesy Camden Art Centre. Photo © Andy Keate

72 Courtesy of the artist and neugerriemschneider, Berlin. Photo: Studio Olafur Eliasson

75 © Phyllida Barlow, Tate. Courtesy Hauser & Wirth, Tate

77 © Olia Lialina

78–9 © Rudolf Stingel. Guy Bell/Alamy Stock Photo.

81 © Anish Kapoor. All Rights Reserved, DACS 2021. Photo © Tate

82 © Melanie Manchot, courtesy of Parafin, London and Galerie m, Bochum

86 © Estate of Rose Finn-Kelcey. Photo © Tate

89–91 Courtesy of the artist

92 Carl De Souza/AFP via Getty Images. © DACS 2021

95 © Alex Da Corte, courtesy Sadie Coles HQ, London

96–7 Courtesy of the artist. Photo © Tate

98 © The Estate of Mildred Thompson. Courtesy Galerie Lelong & Co, New York. Photo: Georgia Museum of Art, University of Georgia; The Larry D. and Brenda A. Thompson Collection of African American Art. GMOA: 2012.152

101 © Mona Hatoum 2021. Photo © Tate

105 Zackary Drucker and Rhys Ernst, *Relationship #23 (the Longest Day of the Year)* 2011. Courtesy of the artists and Luis De Jesus, Los Angeles

106 © 2017 Parker Bright. Photo © Michael Bilsborough

109 Courtesy of the artists. Photo © Institute For Figuring

110–11 © Bharti Kher. Photo: Ros Kavanagh

Acknowledgements

A pandemic is the best and worst time to write a book. I could never have completed this without the love and support of my family, friends and colleagues. In particular, I would like to thank all the team at Ilex and Octopus Books, and especially Ellie Corbett for her dedication, equanimity and patience throughout, Rachel Silverlight for her astute and ingenious edits and Giulia Hetherington for her resourceful picture research. I am very grateful for the generous and thoughtful feedback of early readers of the manuscript: Kyung An, Eleanor Bauer, Jill Cerasi, Duygu Demir and Nadia Ragozhina, as well as the encouragement and advice of my lockdown virtual writing companion, Jason Waite. I am also indebted to many conversations with colleagues past and present at the UK Government Art Collection and the Guggenheim Abu Dhabi project, which have informed my approach to many of the topics covered here. Finally, as ever, I would like to extend my gratitude to all the artists who so kindly allowed me to include their work here, and the countless others who I would have loved to include besides – thank you!